CHINESE
PAINTING TECHNIQUES
for Exquisite Watercolors

Lian Quan Zhen

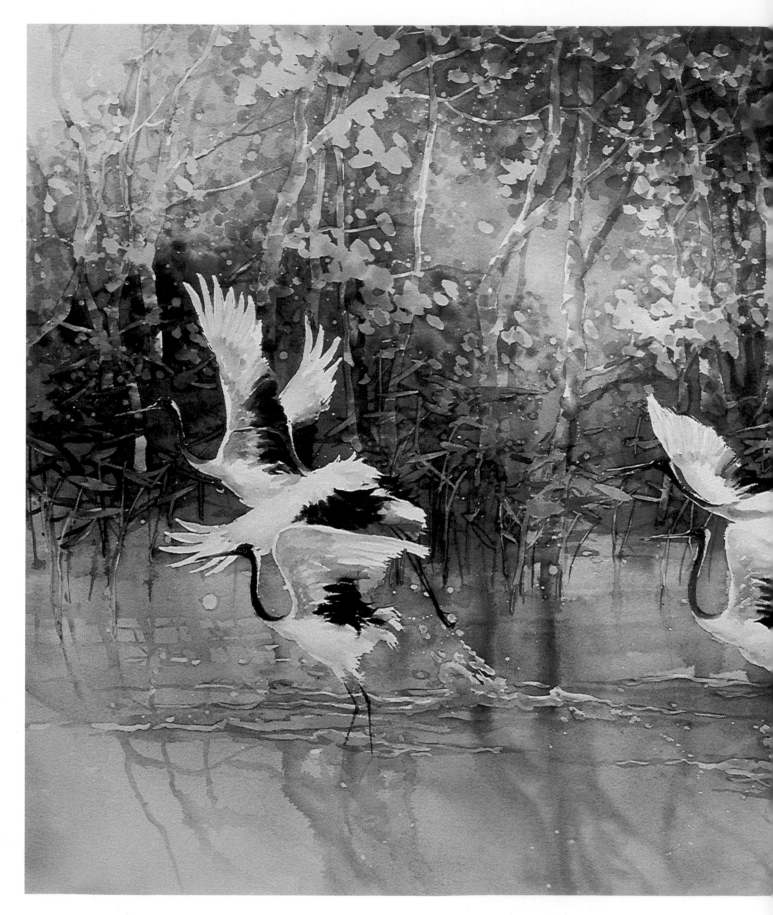

HARMONY
29" x 21" (74cm x 53cm)

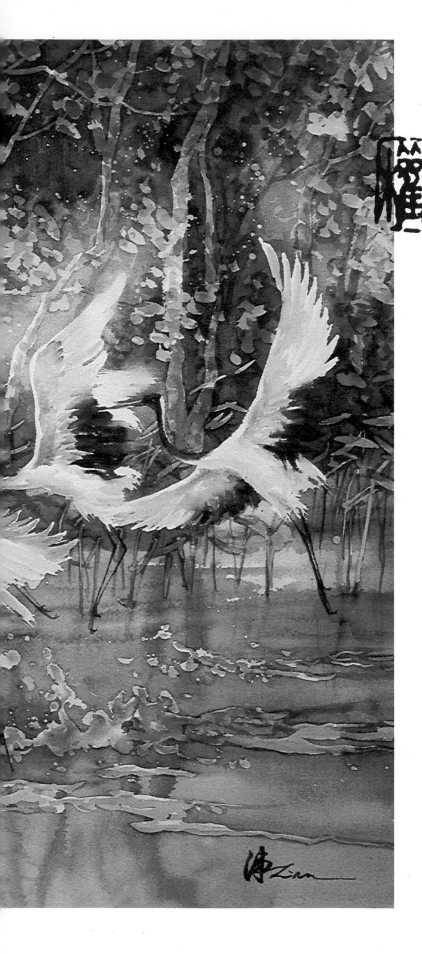

Lian Quan Zhen

CHINESE
PAINTING TECHNIQUES
for Exquisite Watercolors

NORTH LIGHT BOOKS
CINCINNATI, OHIO
www.artistsnetwork.com

About the Author

Lian Quan Zhen was a physician in Canton Province, China. He started sketching and painting when he was ten. He is a self-taught artist who learned Chinese painting techniques in his native country. After he immigrated to the United States, he focused on watercolor painting in addition to Chinese art. In 1992, he received a Bachelor of Arts Degree from the University of California, Berkeley, and in 1996, a Master of Architecture Degree from the Massachusetts Institute of Technology (MIT).

Throughout the past decade, he has held one-man shows in California, Louisiana, Massachusetts and Hong Kong. MIT Museum has collected fourteen of his paintings. His paintings are also found in corporate and international private collections. In 1997 and 1998 he received the International Animal in Arts Competition awards. He has been featured in *Watercolors '94*, Spring Issue, *Collectors* (Hong Kong) and *Splash 4*, published by North Light Books.

Lian teaches watercolor outdoor sketching at the University of California at Berkeley. He conducts workshops nationwide and on-site sketching in China. He has been an invited juror for art shows. For information on his paintings and workshops, see his Web page (www.lianspainting.com), send E-mail to lianzhen@yahoo.com, or write to Zhen Studio, P.O. Box 33142, Reno, Nevada 89533.

Chinese Painting Techniques for Exquisite Watercolors. Copyright © 2000 by Lian Quan Zhen. Manufactured in China. All rights reserved. No part of this book may be reproduced in any form or by any electronic or mechanical means including information storage and retrieval systems without permission in writing from the publisher, except by a reviewer, who may quote brief passages in a review. Published by North Light Books, an imprint of F&W Publications, Inc., 4700 East Galbraith Road, Cinicnnati, Ohio, 45236. (800) 289-0963. First paperback edition 2004.

Other fine North Light Books are available from your local bookstore, art supply store or direct from the publisher.

08 07 06 05 04 5 4 3 2 1

Library of Congress has cataloged hardcover edition as follows:

Zhen, Lian Quan
 Chinese painting techniques for exquisite watercolors/Lian Quan Zhen.—1st ed.
 p. cm
 Includes index.
 ISBN 1-58180-000-2 (hc.: alk. paper); ISBN 1-58180-637-X (pb.: alk. paper)
 1. Watercolor painting, Chinese—Technique. I. Title.
ND2068 .Z48 2000
751.4'251—dc21

 00-029220
 CIP

Editors: Amy J. Wolgemuth and Michael Berger
Cover and Interior Designer: Amber Traven
Production Coordinator: Kristen D. Heller

METRIC CONVERSION CHART

TO CONVERT	TO	MULTIPLY BY
Inches	Centimeters	2.54
Centimeters	Inches	0.4
Feet	Centimeters	30.5
Centimeters	Feet	0.03
Yards	Meters	0.9
Meters	Yards	1.1
Sq. Inches	Sq. Centimeters	6.45
Sq. Centimeters	Sq. Inches	0.16
Sq. Feet	Sq. Meters	0.09
Sq. Meters	Sq. Feet	10.8
Sq. Yards	Sq. Meters	0.8
Sq. Meters	Sq. Yards	1.2
Pounds	Kilograms	0.45
Kilograms	Pounds	2.2
Ounces	Grams	28.4
Grams	Ounces	0.04

Acknowledgments

Many thanks go to Shirley, my wife, who worked overtime and six days a week to support our family during the time I studied in the colleges; to Amery, my daughter, who was quiet in the nights when I was painting and studying during her baby and toddler years. She also contributed her art to this book.

My thanks also go to the following: Mr. Chang, my high school teacher in China, risked his political life to unlock the door of the art materials storeroom for me so I could learn painting during the Cultural Revolution. I regret he could not live to see this book. Professor Sim Van de Ryn has greatly influenced my art in a positive way. My teacher and friend Karin Payson gave me confidence through her encouragement. Professor Ellen T. Harris, Liz Connors and Susan Cohen promoted my art career. Professor Vernon Ingram and Beth Ingram allowed me to exhibit my paintings in their home.

Ray Fugatt and Michelle Fugatt, thank you for introducing and promoting my paintings in Louisiana. Grace Clark, Marjorie Haggin, Nancy Thompson, Sue Clanton, Irene Pearson and Imogene Dewey, your hard work has made many of my workshops possible. Carole Hilton and Paddy J. Johnston, thank you for taking your valuable time to proofread my manuscripts.

I also thank Rachel Wolf for her recognition of my paintings and for making this book possible through North Light Books, and Amy Wolgemuth and Michael Berger, my editors, who patiently edited my Chinese version of English writing.

Finally, I thank numerous collectors who love and own my paintings, and all my friends and students who have helped me in different ways to finish this book, my dream come true.

 To the memory of my mom, who taught me to be a good man. To my wife, Shirley, and my daughter, Amery, who both love and support me from their hearts.

1 CHINESE PAINTING BASICS

page 10

�֍ The Six Laws

�֍ Three Categories of Chinese Paintings

�֍ Three Styles of Painting

�֍ Materials

✖ Using Your Materials

✖ Brushstrokes

✖ Stretching Your Paintings

2 CHINESE PAINTING COMPOSITION & BASIC PAINTING TECHNIQUES

page 26

✖ Composition Methods

✖ Detail-Style Painting Techniques

✖ Spontaneous-Style Painting Techniques

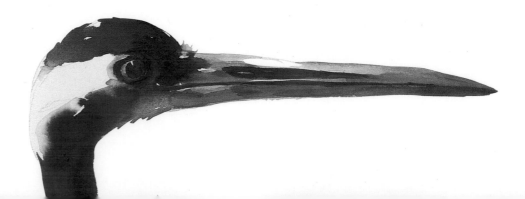

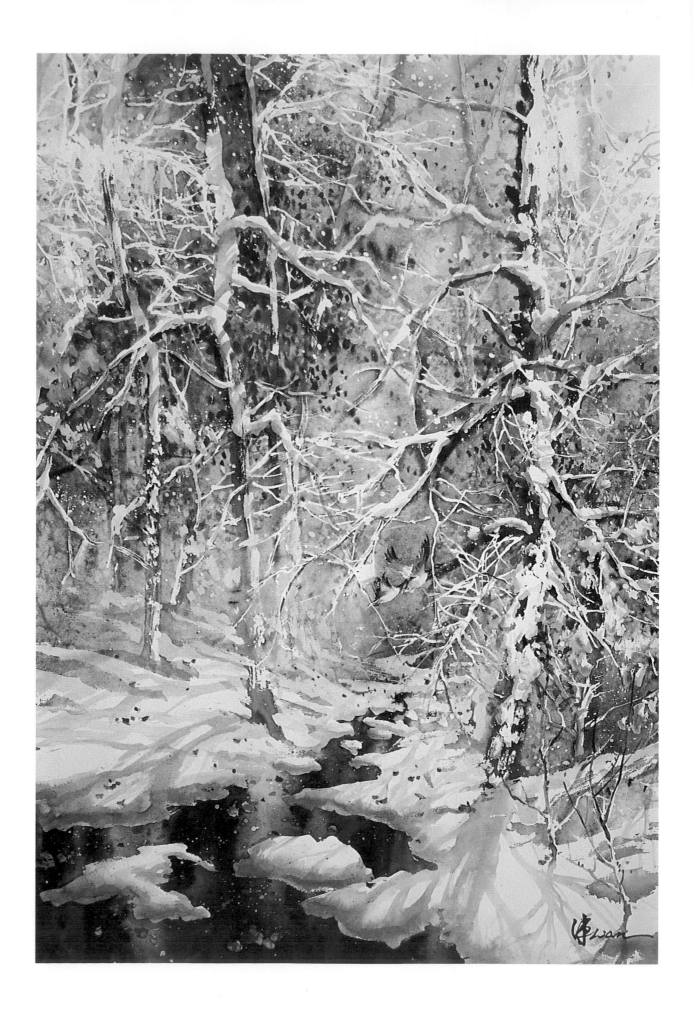

Foreword

Lian Zhen is a rare and wonderful talent. Trained as a physician in China, he has always had a love for classic painting, calligraphy and the natural world. I came to know Lian as a student in my architectural classes at the University of California, Berkeley, and later in my outdoor watercolor sketching class where I encouraged him to discover his own style; he, in turn, introduced me to the classic tradition in Chinese painting, which he shares with you in this book.

This book is his gift to you, a sharing of his deep knowledge, passion and skill in an ancient tradition interpreted through his unique vision. Lian is a compassionate and enthusiastic teacher. Enjoy this book and learn from Lian's art!

Sim Van de Ryn
Professor Emeritus
University of California, Berkeley

SNOW
21" x 29" (53cm x 74cm)

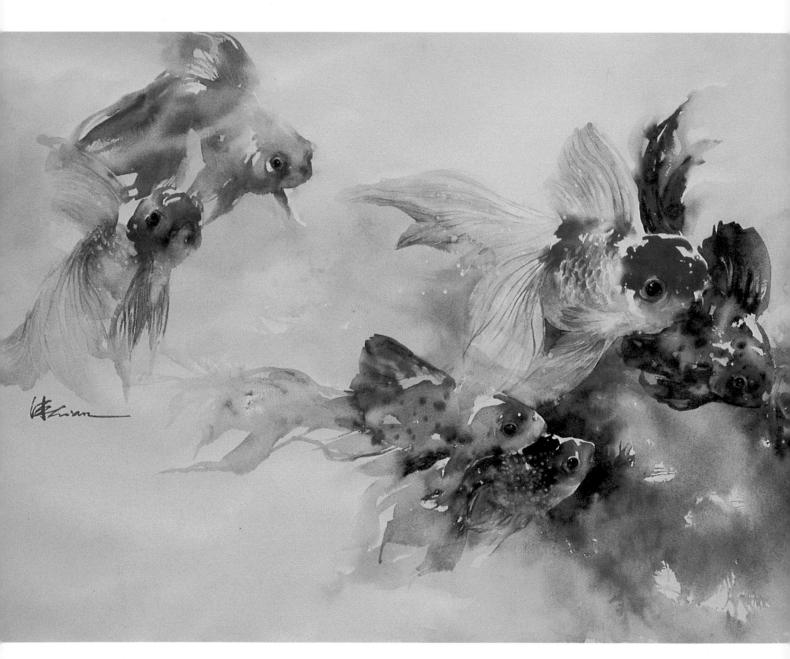

GOLDFISH
40" x 29" (102cm x 74cm)
Watercolor on Arches 140-lb. (300gsm)
cold-press watercolor paper
Color pouring and blending

CHINESE PAINTING
BASICS

1 What is a Chinese painting? A Chinese painting is mainly line art painted with a Chinese brush, ink and colors on rice paper or silk. Often, the painting is in linear perspective. On the painting, there is Chinese calligraphy that inscribes the name of the painting, a poem and the artist's signature, along with a red chop. (A *chop* is similar to a rubber stamp that contains the artist's name or a phrase.)

Traditionally, Chinese artists define objects with lines rather than surfaces. They mainly use ink to paint. The idea of simplicity from both Taoism and Buddhism deeply influences artists who consider other pigments as secondary media that serve the purpose of perfecting the ink.

THE SIX LAWS

During the Eastern Tsin dynasty (A.D. 317–420), Hsieh Ho, an artist and the first art critic in Chinese history, established the Six Laws of Painting. First, *vitality resonates from a painting*. This means that a painting should carry lively forces that touch viewers.

Use bone manner brushstrokes, or brushstrokes that are confident, strong and elastic. They should resemble bones in content—not necessarily uniform, but strong in texture.

Capture the forms of nature's objects. In other words, sketch nature with the intent to capture its forms and spirits.

Apply colors according to each object's category. When painting a group of trees, there is no need to differentiate each tree's color. Paint all of them using one color, such as green or yellow.

Properly place the objects. A great painting has a well-organized composition.

Transfer masters' techniques. Learn from the masters by copying and analyzing their artwork. As a result, you will learn a variety of techniques and theories with which you can develop your own.

The first law is most significant. It seeks to blend the artist's spirit with the rhythmic vitality of nature. A great painting should not only demonstrate outstanding technique, but should also express harmony and vitality. When painting a bird, it does not matter how much detail your painting has, nor what technique and media are used. It is essential to capture the *essence* of the bird: its texture, activity and sound—its life. The bird should be able to communicate with its viewers.

Chinese artists are encouraged to learn from nature. If you paint landscapes, for example, then practice sketching as many magnificent landscapes as you can. Likewise, if you paint fish, then observe fish as often as possible.

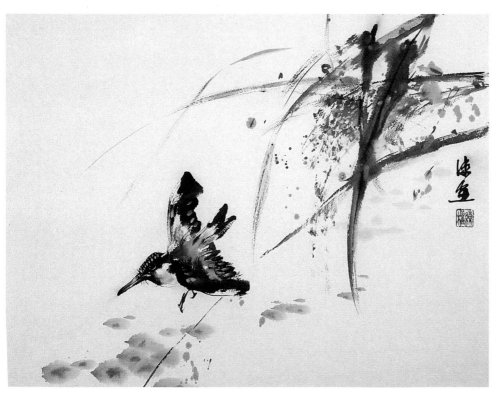

Using the Six Laws
This painting further explains the Six Laws. It depicts the moment just before the kingfisher catches a fish. It is a vivid painting that captures harmony in nature (first law). The minimal brushstrokes are sure and forceful (second law). The bird is lively and energetic, and is derived, rather than copied, from nature (third law). The colors on the water plants are uniform, according to category (fourth law). The objects are arranged on a diagonal line from bottom left to upper right to further emphasize the motions. The white area in the kingfisher's direction of flight allows viewers to use their imaginations (fifth law). Finally, the painting techniques are influenced by the Lingnan School (sixth law).
FISHING
18" x 22" (46cm x 56cm)
Chinese ink and colors
on Korean paper
Spontaneous style

THREE CATEGORIES OF CHINESE PAINTINGS

Figures

Figure paintings focus on people, although other objects, such as rocks, trees and flowers, also appear. The golden age of figure painting occurred during the Sui and T'iang dynasties (A.D. 589–906). Artists used a variety of beautiful brushstroke styles with descriptive names to emphasize textures and the movement of clothes, and to capture the essence of the figures. For instance, iron wire strokes were uniform, strong and threadlike. Moving cloud and flowing water strokes were fluent, long and thin with soft turning angles. Bramble brushstrokes were thick, large, broken and abbreviated. Typically, only one brushstroke style was used to paint the figures in a painting.

Landscapes

Landscape paintings are dominated by mountains, clouds, rocks, trees, bridges, houses, waterfalls, rivers and boats. People are small in these paintings. Landscape painting reached its prime during both the Five Dynasties period and the Northern Sung dynasty (A.D. 906–1127).

Floral/Bird

Floral/bird paintings include flowers, rocks, creeks, grass, insects, birds, fish and other small objects. Similar to landscapes, these paintings gained popularity during the Five Dynasties (A.D. 906–960) and flourished in both the Northern and Southern Sung dynasties (A.D. 960–1279).

LOVE DANCING
27" x 38" (69cm x 97cm)
Watercolor on Arches 140-lb. (300gsm)
cold-press watercolor paper
Color pouring and blending

THREE STYLES OF PAINTING

Detail Style

Detail-style paintings show a lot of small details. For example, in bird and fish paintings, feathers and scales are clearly depicted. Artists handle their brushes carefully and slowly, and the brushstrokes are smaller and more uniform than in other styles of painting. In addition to ink, vivid and intense colors are also used. Artists use surfaces that do not absorb water, such as alum rice paper and alum silk.

Detail style is the basic training for Chinese painting students. It teaches them to manipulate their brushes to acquire proper strokes, to observe and analyze details and to use colors.

Spontaneous Style

Also known as scholar style, this type of painting is strongly influenced by Chinese calligraphy and poetry. It remains the dominant style since its full development during the Sung dynasties. According to scholar-style painting theory, poetry, calligraphy and painting (the *three perfections*) are inseparable. A great artist should master them all.

Spontaneous-style artists reinterpret rather than copy nature. They manipulate brushstrokes in an abbreviated manner. As a result, spontaneous-style paintings can be semiabstract and may use metaphors to depict the essence and spirit of objects without emphasis on details. Breaking a mountain into segments in a landscape, for instance, is a traditional metaphor for losing one's homeland. Bamboo symbolizes honor and

Spontaneous-Style Painting
This spontaneous-style painting shows no small details. The brushstrokes are not uniform as in the detail-style painting, and the variety of strokes suggests texture and movement. Notice how the tails and fins of the goldfish are defined by wide brushstrokes rather than outlines.
BEAUTY OF FREEDOM
17" x 24" (43cm x 61cm)
Chinese ink and colors on double-layer raw Shuan paper
Spontaneous style

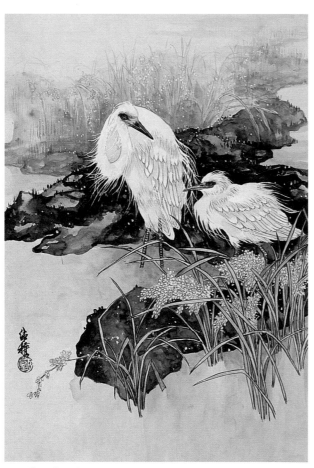

Detail-Style Painting
This typical detail-style painting depicts small details, such as the egrets' feathers and individual rice grains. The objects are painted with outlines and then filled in with colors.
TWO EGRETS
11" x 17" (28cm x 43cm)
Chinese ink and colors on mature Shuan paper
Detail style

dignity, while palm flowers are symbolic of encouragement and nobility. Orchids connote high morality. If an artist gives you an orchid painting as a gift, most likely the artist considers the relationship between you and him as pure and strong.

The ink-pouring technique, created by a famous drunken artist named Wong Mo during the T'iang dynasty (A.D. 618–906), could be considered the extreme of the spontaneous style. Before Wong Mo would begin to paint, he would first drink a lot of wine. Then he would start pouring ink on silk, laughing and chanting all the while, smearing his hands and feet across the silk while he danced. When the images revealed themselves, he adjusted and transformed them into mountains, bridges, trees, houses, rocks and figures. Unfortunately, none of his paintings survive today. I have tried Wong Mo's technique and must admit it's a lot of fun; however, I did not drink while I was painting.

Half-Detail, Half-Spontaneous Style

Obviously, this style is a combination of the detail and spontaneous styles. Some artists like to paint floral-bird paintings in this style. The paintings are not exactly equally half of each style. In most cases, the focus objects are in detail style and the others are in spontaneous style.

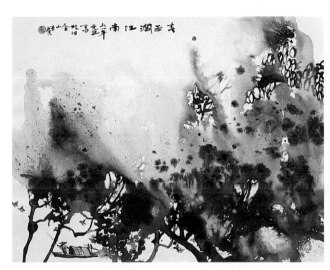

Having Fun With Ink Pouring
I knew I wanted to paint a scene with trees. However, I did not have a composition in mind. I started by wetting the upper and middle portions of the paper with a water sprayer. I then poured Ultramarine Blue, Pure Cadmium Yellow Light and Cadmium Red Deep on the upper part of the paper. Next, I poured Chinese ink along the bottom of the colors and left the colors and the ink to blend for about half a minute. Then I tilted the paper so the colors and ink would flow toward the bottom to create the branches and trunks. I further defined the trees with a medium brush and added a few birds, a boat and a boatman.
SPRING RAIN
10" x 14" (25cm x 36cm)
Chinese ink and color on Académie sketch paper
Spontaneous style

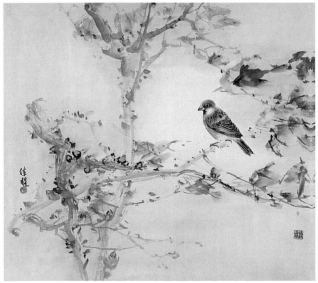

Half-Detail, Half-Spontaneous Style
Notice in this painting how the sparrow is in detail style while the tree and background are in spontaneous style.
SPARROW
28" x 28" (71cm x 71cm)
Chinese ink and colors on mature Shuan paper
Half-detail, half-spontaneous style

MATERIALS

Getting the right materials is a good start to learning Chinese painting. Rice paper, bamboo brushes, ink sticks and ink stones are the traditional materials. They are also the materials for writing and calligraphy. Chinese refer to them as the *four treasures of a scholarly library*. You may realize that colors are not listed as one of the basic materials. Chinese artists consider ink as a color because they dilute the ink with water to create a number of tones. Chinese artists are judged by how well they manipulate different tones of ink. This is not difficult to understand if you have made pencil sketches. The more tones you have on your sketch, the more depth your art will possess.

Most of these materials are available in Chinese bookstores and art galleries in Chinatowns. I bought all my materials in Chinatown in San Francisco. In addition, some major art supply stores carry basic Chinese painting materials such as rice papers, brushes, ink sticks and ink stones.

Rice Paper

The rice paper I used for most of the Chinese painting demonstrations in this book is called *Shuan paper*, produced in Jing County, Anhui Province. There are two kinds of Shuan papers: raw and mature. Raw paper is untreated, soft and very absorbent, and is used mainly for spontaneous-style paintings. It comes in either a single, highly absorbent layer, or a double, gently absorbent layer. Start painting on the double-layer Shuan paper when you paint in spontaneous style, as the paper is easier to control than the single-layer paper.

Mature Shuan paper is made by applying alum to both sides of the raw Shuan paper. It is also soft, but not absorbent, making it great for detail style and half-detail, half-spontaneous style.

Korean and Other Papers

Korean paper can also be used for spontaneous-style paintings. It is similar to the raw Shuan paper in absorbency. However, it is more resistant to tearing and blends ink and colors differently. I also paint on Western art papers, such as Arches 140-lb. (300gsm) watercolor paper and Academie sketch paper. I'm not concerned whether those paintings are considered Chinese paintings or not. To paint is to create, and creation usually begins without names.

Brushes

Chinese brushes are made with animal fur tips and bamboo handles. There are three groups of brushes: soft, medium and hard. Soft brushes are made of soft furs, such as goat. The hard brushes are made from furs such as wolf and horse. A brush made of both soft and hard furs is considered of medium texture. Artists tend to use their favorite kinds of brushes. As a new student, the rule of thumb is to use soft brushes for painting soft-textured objects, such as flowers, and for coloring. Use hard brushes for painting rough-textured objects, such as rocks and tree trunks, and for detailing. It is handy to have all three kinds of brushes in sizes from small to large. Unlike watercolor brushes that have a numbering system, Chinese brushes are simply defined as small, medium or large. You can refer to the numbers on Japanese Sumi brushes for comparison. A small Chinese brush is the same size as a Sumi no. 4 brush. A medium brush is similar to a

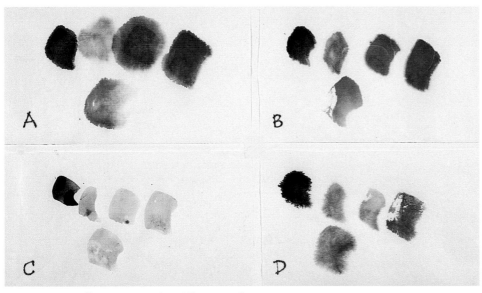

Different Papers Give Different Results
Notice how the colors respond differently on these four types of paper.
A. Raw Shuan paper (single layer)
B. Raw Shuan paper (double layer)
C. Mature Shuan paper
D. Korean paper

Sumi no. 6, and a large brush is equal to or larger than a Sumi no. 12. Before you use a new brush, soak the brush tip in clean, cold water for one-half to one hour. The water will remove the glues that adhere the fur together. This creates an *open brush*.

Ink and Ink Stone

For hundreds of years, Chinese artists ground ink sticks with clear water on ink stones to get ink for painting, calligraphy and writing. The ink sticks for painting are made of rosin soot from burning oil, and are called *old-smoke ink sticks*. Ink stones are made of natural rock. They are not only tools for making ink but also collectible sculptures. The best ink stones are called *Twan ink stones*, quarried in Twan County, Canton Province. If there are circular spots with light earth color on an ink stone ("eyes"), the rock is a good age and carries the best textures for producing higher-quality ink. This kind of ink stone costs much more than regular ink stones. As a beginner, you need only a regular ink stone.

It sounds complicated to produce ink before you start painting. Actually, during the time you are grinding the ink stick, you are calm and able to compose your painting. It is a meditation period before painting. In recent years, bottled ink has become available. Many artists use it because it is of good quality and is easy to carry while traveling. I used bottled ink for the Chinese paintings and demonstrations in this book. Its brand name is China Ink, made in Shanghai.

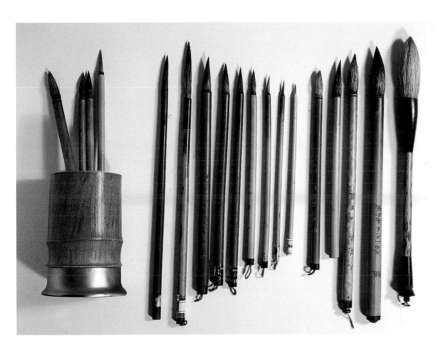

Chinese Brushes
The five brushes on the right are soft brushes, while the others are hard and medium. I use the middle four small brushes a lot when I paint detail-style paintings. A brush container is on the left.

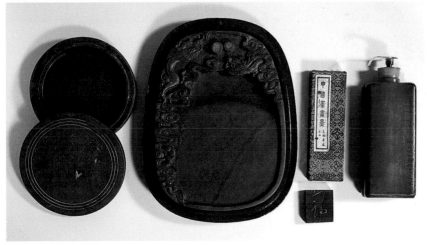

Ink Stones and Inks
A. A common ink stone (4" [10cm] diameter) and its cover.
B. A Twan ink stone with two "eyes" near its top, along with a cloud-pattern relief sculpture. The stone has a wooden base and cover, though the cover is not shown here.
C. An ink stick with only one-third of its original length left. (Its box is above.)
D. The China Ink bottle.

Colors

Similar to watercolors, modern Chinese paints come in tubes. I use Chinese Painting Color, produced by SIIC Marie Painting Materials Co., Ltd., Shanghai. I use nine of the pigments frequently: Blue (light blue), Burnt Sienna, Carmine (deep red), Cinnabar, Gamboge (yellow), Green (light green), Indigo, Vermilion and White. The colors are water based and made of plants and minerals, along with glue. Do not use regular watercolor pigments, as they will blend during the process of stretching the painting.

Chops and Rouge

Chops are used for sealing paintings and balancing compositions, and are usually made of soapstone. An artist often has one name chop and a few leisure chops, which are inscribed with short phrases or poems. I carved about ten chops for myself fifteen years ago. You can have your own chops made at many Chinese art galleries, where artists can help you to translate your English name phonetically into a Chinese name and carve it on a soapstone.

Rouge is oil-based red color used for stamping, and comes in various-sized jars with covers so that it will not dry out.

Other Materials

Besides the materials already discussed, you'll need a few other things:

- ❀ A china palette or several small white china dishes to use as palettes (a watercolor palette can also be used)
- ❀ A painting mat made from smooth, 1/8" (3mm)-thick, light-colored fabric to cover your painting table
- ❀ One or two watercolor brush washers (or containers of water)
- ❀ A brush container
- ❀ A brush holder for resting your brush
- ❀ One pair of paperweights for leveling the Shuan paper, as it is not as flat as watercolor paper

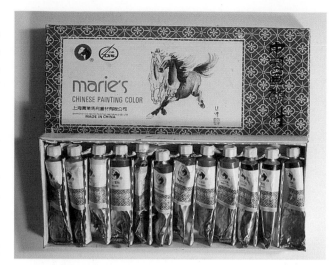

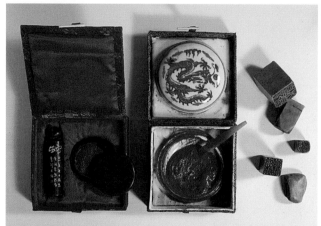

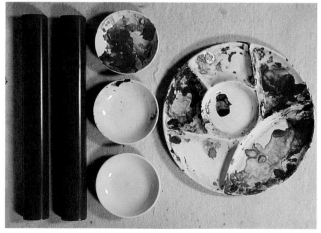

Chinese Colors

Typical Chinese painting colors come in tubes 3½" (9cm) long by ¾" (19mm) in diameter. Another size of Chinese colors not shown here is about half that size, and is sold either in a set or individually. I prefer the larger tubes because they do not harden as quickly as the smaller ones.

Chops and Rouge

A. This box holds a chop of my daughter's name. Since she was born in the year of the snake, she chose a chop with a little snake at one end.
B. This box holds a large china jar with rouge.
C. Here are several chops I made.

Other Painting Supplies

A. A small painting mat, 20" x 20" (51cm x 51cm).
B. Two 1½" x 12" (4cm x 31cm) wood paperweights.
C. Three small white china dishes I use to mix colors.
D. Chinese painting palette (china).

USING YOUR MATERIALS

Laying Out Your Materials

You should have a table for Chinese painting. I use a 30" x 72" (76cm x 183cm) folding table. There is no one way of laying out the materials on your painting table. Place them according to convenience. I lay them out nicely before I paint. But by the time I finish, they're all over the place!

Holding the Brush

Holding the brush is not the same as holding a pen or pencil. When you hold the brush correctly, you can get desired brushstrokes much easier. Hold the brush with your thumb, index and middle finger. When your fingers hold up the brush, there is a hollow space between your fingers and your palm. This allows the brush to move freely while it is tight in your fingers.

In my Chinese painting workshops, many students hold their brushes correctly for an hour or so then go back to the way they hold a pen because they feel tired. Keep practicing for a while; you will get used to the correct way. Interestingly, since I have done Chinese painting for a long time, when I paint details in watercolor, I hold my watercolor brushes in the same way I hold a Chinese brush. I feel it is easier to achieve the best results.

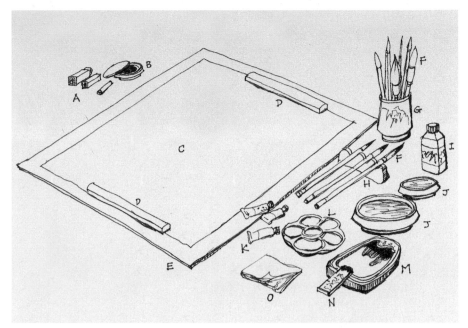

Laying Out Your Materials

Here's how I lay out my materials as I prepare to paint—though by the time I'm finished, things tend to be scattered quite a bit.

A. Chop
B. Rouge
C. Paper
D. Paperweights
E. Painting mat
F. Brushes
G. Brush container
H. Brush holder
I. Bottle ink
J. Brush washer
K. Colors
L. Palette
M. Ink stone
N. Ink stick
O. Paper towel

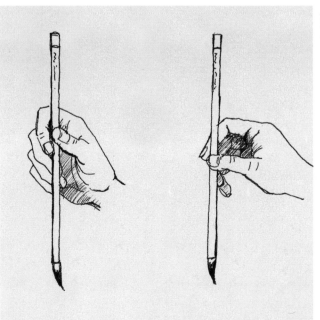

Holding the Brush

Here's the correct way to hold a brush.

BRUSHSTROKES

Good brushstrokes should be confident, without uncertainty. They should have proper tone and the right amount of moisture. They should be strong, energetic and elastic to suggest texture.

Let's use the bird painting to the right as a way to explain brushstrokes. I painted the bird and bamboo with sure, vivid strokes. The strokes are a combination of dry and wet textures in different tones. They appropriately suggest the bird's feather texture, its activity and the bamboo's movement.

Proper Brush Angle

There are two proper brush angles. One is vertical, approximately 90° from the painting surface. This position is called *center brush*. The other angle is less than 80°. It is referred to as *side brush*. When you hold the brush vertically, you are able to create fine, rounded, uniform and elastic strokes. The side-brush method is used for outlining and detailing, as well as for painting soft-textured objects. When you paint with the side-brush method, you may tilt the brush at different angles. The narrower the angle, the wider the stroke you get. Use side brush to create rough, dry and active strokes and for painting rocks, mountains, tree trunks, weeds and fast-moving objects.

Moisture

The more water in a brush, the damper and smoother the brushstrokes. On the other hand, with less water, you can obtain broken, rough and aged effects.

Pressure

Applying appropriate pressure on a brush is also important. One guideline is for painters to seek quality brushstrokes with the "power of breaking through the paper." Such power is achieved by transferring your strong internal energy to the brush, then to the strokes, without actually breaking the paper.

MORNING SONG
11" x 13" (28cm x 33cm)
Chinese ink on Academie sketch paper
Spontaneous style

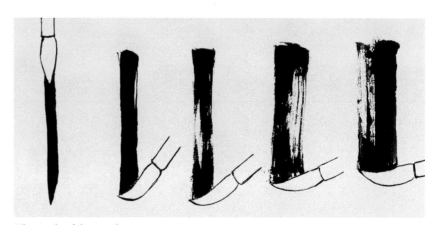

The Angle of the Brush
The brush at left is being held at 90°. The others are being held at various angles.

Stance

It is a good idea to stand when you are painting. Hence you can transfer your energy from your body to your arm and your fingers, then into the brushstrokes. Try to move your arm more often than your fingers because it is easier to control the movement.

Moving Speed

Speed affects the characteristics of strokes. The faster you move your brush, the more effects will be created by the strokes.

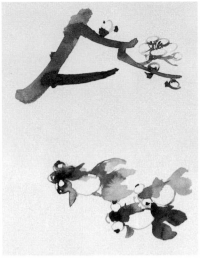

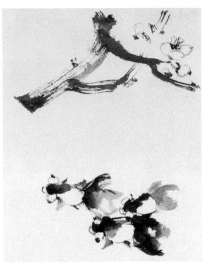

Wet Brushstrokes
A palm branch with blossoms and three goldfish painted using wet brushstrokes.

Dry Brushstrokes
The same branch and goldfish, this time painted using dry brushstrokes.

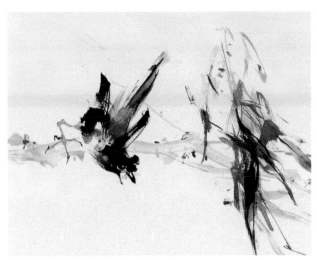

WHERE ARE YOU?
10½" x 13" (27cm x 33cm)
Chinese ink on Academie sketch paper
Spontaneous style

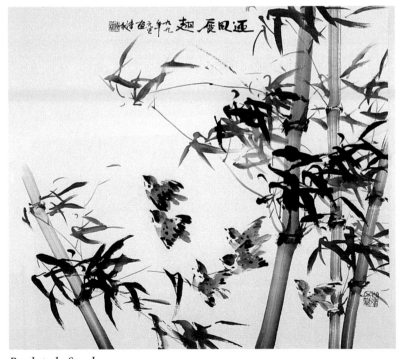

Brushstroke Speed
The bamboo leaves, sparrows' wings and tails are painted with fast-moving strokes to suggest the blowing wind during flight.
BEGINNING OF A JOURNEY
30" x 30" (76cm x 76cm)
Chinese ink and colors on double-layer Shuan paper
Spontaneous style

STRETCHING YOUR PAINTINGS

Once you have completed your paintings, they will need to be stretched, as undoubtedly the paper will have wrinkled due to water absorption. Even though stretching Chinese paintings can be tricky, you can do it in a simple way that will give you wonderful results.

What You'll Need

Most of the materials you'll need are fairly common and easy to come by:

❋ One 7" (18cm) cooking pot

❋ A roll of paper towels

❋ A clean 10" (25cm)-diameter plate

❋ A 3-inch to 6-inch (76mm to 152mm) flat soft-fur brush

❋ One ¾-inch flat watercolor brush

❋ One water spray bottle

❋ Wheat starch (Use one with a neutral pH so that it will not discolor or disintegrate over time. You can buy it from most art supply stores.)

❋ A stretching surface (I use Plexiglas because it is smooth and even. I have two sheets of Plexiglas: one is 24" x 36" [61cm x 91cm] for small paintings, and the other is 40" x 72" [102cm x 183cm] for large paintings.)

❋ A stretching board made from ½" (12mm)-thick particleboard or plywood, the same size as or larger than the Plexiglas

❋ A clean, smooth and even mounting surface for drying (I use a 4' x 8' [122cm x 244cm] sheet of particleboard.)

Preparing the Stretching Surface

Place the stretching board on a table, and draw rectangular guidelines on it. At a point about 5" (13cm) from both the right and bottom edges, mark the lower right point of the rectangle. From this starting point, draw a 20" x 35" (51cm x 89cm) rectangle parallel to the bottom edge and the right side of the board. Use waterproof marker to keep the lines from bleeding onto your artwork.

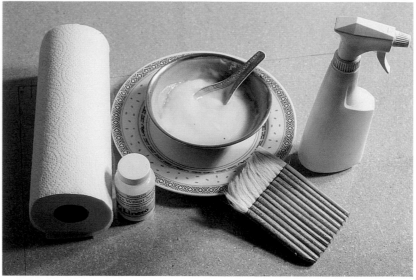

What You'll Need
A roll of paper towel, one bottle of neutral pH pure wheat starch, a 7" (18cm) stainless steel bowl with cooked gravy, a 10" (25cm) plate, a 5-inch (13cm) flat brush and a water spray bottle.

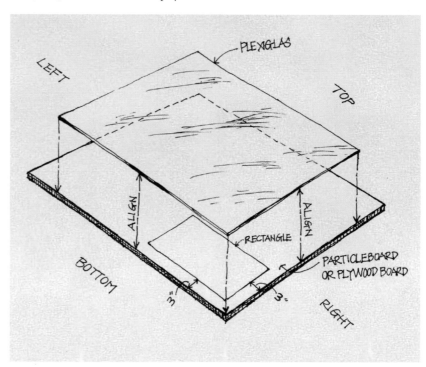

Building the Stretching Board
This diagram shows the stretching board, the rectangle and the Plexiglas.

Lay the Plexiglas on top of the stretching board. Align both the right and bottom edges of the Plexiglas and the stretching board.

Preparing the Stretching Gravy

I usually stretch several paintings at one time. The amount of gravy I am preparing (right) is for eight paintings in a variety of sizes. I needed about ¼ cup (6ml) of starch and 1¼ cups (30ml) of water. In general, the ratio between starch and water is 1 to 5.

Preparing the Rice Paper Backing

The rice paper backing is for attaching to the backside of your painting. You can use Korean paper or the same kind of rice paper as for your painting. It should be about 3" (8cm) larger all around than the painting you are working with. For this example, I cut a 23" x 30" (58cm x 76cm) piece of raw Shuan paper for the 17" x 24" (43cm x 61cm) painting *The Beauty of Freedom.*

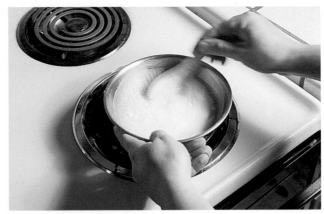

1 MIX THE STARCH AND WATER
Stir the starch and water until they are mixed well.

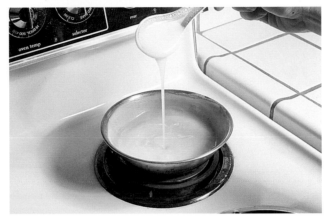

2 BOIL THE STARCH AND WATER
Place the bowl on the stove and heat, stirring the liquid slowly. Once the liquid comes to a boil, remove it from the stove.

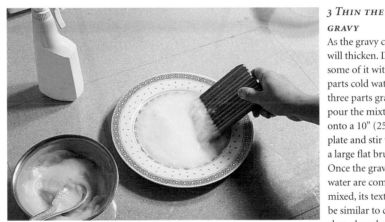

3 THIN THE GRAVY
As the gravy cools, it will thicken. Dilute some of it with two parts cold water to three parts gravy, pour the mixture onto a 10" (25cm) plate and stir with a large flat brush. Once the gravy and water are completely mixed, its texture will be similar to cooked clam chowder, as seen in the bowl on the right. Now it is ready to be used for stretching.

Stretching the Painting

The painting will be totally wet during the stretching process. Since Chinese ink and colors are made with special binders that are absorbed into the rice paper's fibers, there will be very little or no blending of colors when the whole painting is soaked. This is in contrast to most watercolors, which do blend.

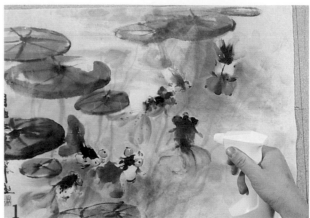

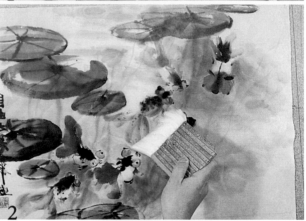

1 WET THE PAINTING

Lay the painting upside down on the Plexiglas, and align the right edge of the painting with the right edge of the rectangle. Locate the midpoints of both the painting and the rectangle. Next, use your water bottle to spray water on the painting lightly (don't totally wet it). As the painting softens and expands, use your fingers to carefully pull on the edges to remove any wrinkles. Then continue to spray more water on the painting until it is wet.

2 APPLY THE DILUTED GRAVY

While the painting is wet, soak the bristles of the flat brush with the diluted gravy and apply it to the painting, holding the brush at a 45° angle. Start brushing from the center of the painting, working outward to the edges. Do not touch the painting with the bamboo handle of the brush or you will break the painting. If the painting forms large wrinkles, use your fingers to lift up a corner, then slowly release it while carefully brushing the wrinkle toward the uplifted edge. Keep brushing the painting until there are no wrinkles and the painting is flat.

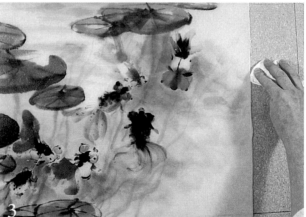

3 CLEAN UP EXCESS GRAVY

Use a paper or fabric towel to clean up, being careful not to touch the painting. Wash the fabric towel with water every time after stretching a painting.

4 ALIGN THE BACKING RICE PAPER

Slide the Plexiglas about 3" (8cm) toward the left side. The right edge of the painting is now 3" (8cm) away from the right edge of the rectangle. Roll up the rice paper backing, then align the right edge of the backing paper with the right edge of the rectangle. Measure the midpoints at the right edges to make sure the rice paper backing and the rectangle overlap each other. Next, press a small portion of the backing down to the painting.

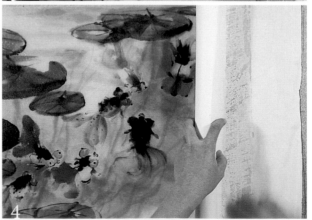

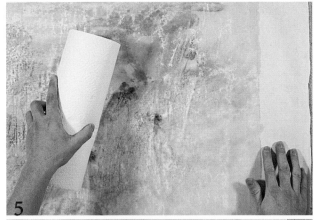

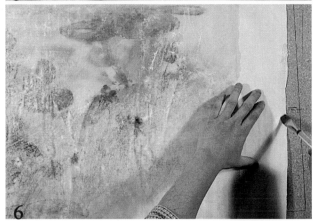

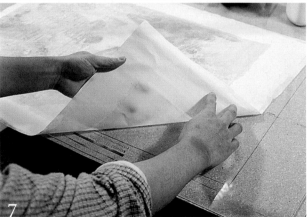

5 ATTACH THE RICE PAPER BACKING

With your left hand, slowly unroll the backing paper while your right hand continually presses it down onto the painting. Cover the entire painting. Immediately use a paper towel roll to smooth and reinforce the attachment of the rice paper backing. Lightly press the roll to the backing and slowly work from the center of the painting toward the edges. Smooth the whole surface of the painting a couple of times.

6 APPLY THICK GRAVY TO THE EDGES

Use your ¾-inch (19mm) watercolor brush to apply the thick gravy (not the diluted one) to all edges of the rice paper backing in about a ¾" (19mm) width. Do not drop the gravy on the rest of the backing.

7 LIFT THE RICE PAPER BACKING AND THE PAINTING

Start lifting both the rice paper backing and the painting, starting at one corner and using both hands. Sometimes the backing will not attach to the painting strong enough to allow you to lift them together. In such cases, release the corner and press it down with your fingers to create a stronger attachment to both the backing and painting. Try to lift the corner again.

8 MOUNT FOR DRYING

After lifting the rice paper backing and the painting together from the Plexiglas, paste the edges of the backing on the mounting surface for drying. I use a large sheet of particleboard. Make sure all perimeters of the backing are securely attached to the surface.

After a few hours to a full day, depending on the temperature of the room where you're working, everything should be dry. At that time, use a sharp blade to cut under the perimeter of the rice paper, separating the painting and backing from the mounting surface. Finally, the stretched painting is ready for matting and framing.

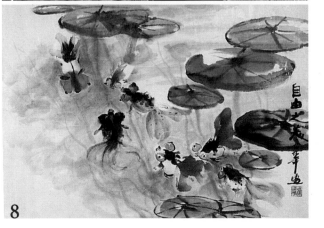

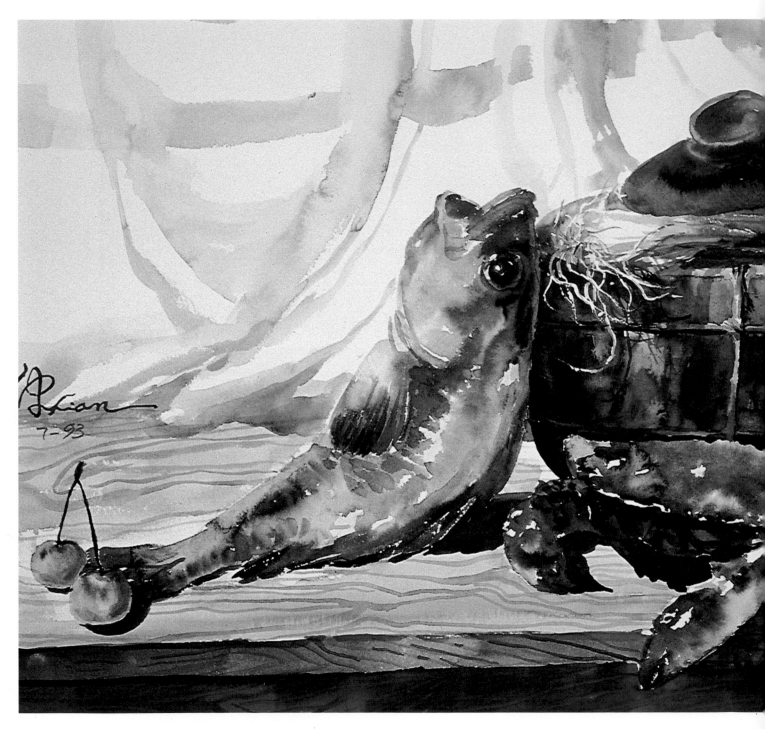

FISH AND CRABS
13¼" x 20" (34cm x 51cm)
Chinese ink and colors on double-layer Shuan paper
Spontaneous style

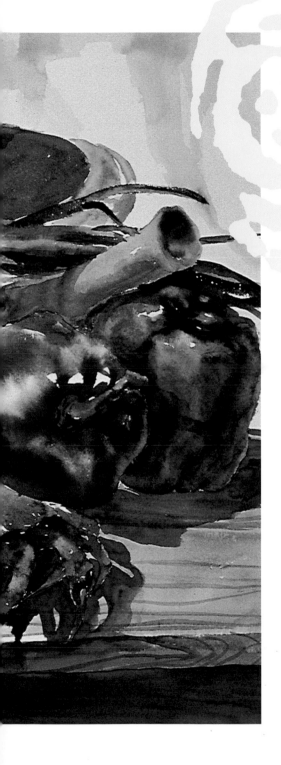

CHINESE PAINTING
COMPOSITION &
BASIC PAINTING
TECHNIQUES

2

Chinese paintings have unique characteristics. Besides the theory and materials, special composition methods and techniques contribute to this distinguished art form. This chapter will introduce you to the composition methods and basic techniques. I recommend that you read this chapter now but practice the techniques when you are in the demonstration chapters.

COMPOSITION METHODS

Chinese painting composition is special in terms of linear perspective; priority of objects; balance and the relationship between line, point and surface; geometric organization; and, finally, placement of calligraphy and chops.

Linear Perspective

Linear perspective is the primary composition method in Chinese painting. It does not create camera-defined views; rather, it generates multi-vanishing-point scenes. For example, when you are close to a large, horizontal fish tank, you move from one end to the other to see the fish. If you combine every portion of what you see from every angle to organize a painting, you will create a linear perspective composition painting. (Imagine taking photos while moving from one end of the fish tank to the other, then laying the photos out horizontally, end to end.)

Priority of Objects

You should clearly define the major and minor objects of your paintings. The *major object* is the focal point of a painting. It should have more details and outstanding colors than the other objects. *Minor objects*, on the other hand, support the major object. They have fewer details and less-intense hues. In most cases, the major object occupies a primary space in a painting. Therefore, it captures viewers' attention. However, the primary object is not necessarily the largest object in a painting or centrally located.

The way of organizing major and minor objects can also be applied to details within individual objects. When painting a bird, for instance, I do not paint its eyes, beak, feathers and legs with the same level of detail; rather, I emphasize one or a few features as focal points of the bird.

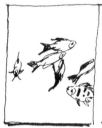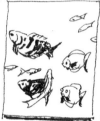

Linear Perspective
These six individual scenes can be put together to form an elongated painting.

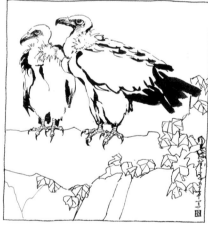

Priority of Features Within an Object
The vultures' heads, eyes and feet are emphasized with more details because they are the primary features that represent the birds' spirits.

Priority of Objects Within a Painting
The goldfish are the primary objects in this painting, so they have more detail than the larger lotus leaves.

28

Establishing Priority

There are five ways to establish priority and emphasize a major object: make it larger, direct eye flow, group small objects, use large to emphasize small, and contrast color.

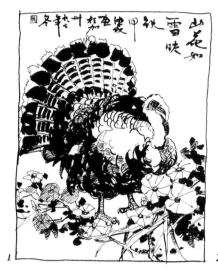

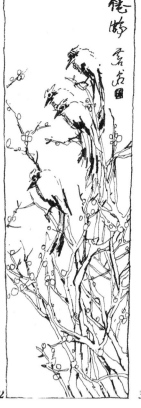

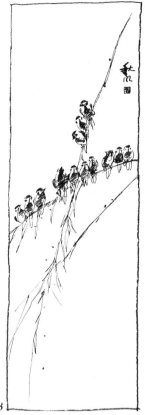

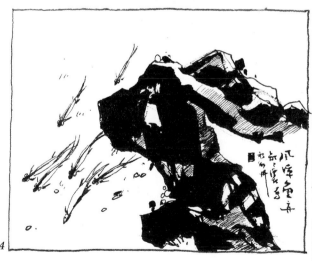

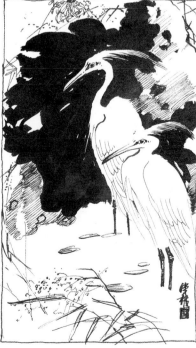

Technique 1: Dominant Objects Paint the major object larger so it dominates the whole composition. In this painting, the turkey completely dominates the composition with its outstanding size. It is the main object. In contrast, the flowers are smaller. They are minor objects.

Technique 2: Directing Eye Flow Use minor objects to direct the viewers' eyes toward the major object. This is useful when choosing a small-scale object as the major object. Here, the branches of the flowering tree point upward. They guide viewers' eyes toward the primary objects: the birds on the top.

Technique 3: Group Small Objects When a major object is too small, paint a group of them as the major object to capture viewers' attention. In this painting, one sparrow is tiny, but two groups of sparrows can form primary objects.

Technique 4: Large Emphasizes Small This is opposite of technique 1. Use large, undetailed minor objects to emphasize the small major object. The big rock in the foreground of this piece occupies more than half of the composition, but it is neither active nor emphasized with details. In contrast, the fish are in motion and they have more details than the rock. As a result, the fish are the primary objects.

Technique 5: Color Contrasting Dark and light, black and white, are contrasting colors. Use them as pairs for strong effects and to emphasize major objects. Here, the lotus leaves are black in the background, making the primary objects, the white egrets, stand out.

Balance

Balance in Chinese painting is relative. It is not simply putting objects in the centers of paintings. When you place an object in the center, the composition is in perfect balance; however, it is not interesting. Objects' weights, colors, activities and surfaces can all determine balance.

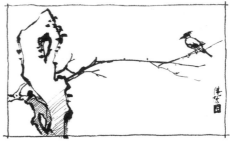

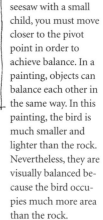

Weight Balance

When you play on a seesaw with a small child, you must move closer to the pivot point in order to achieve balance. In a painting, objects can balance each other in the same way. In this painting, the bird is much smaller and lighter than the rock. Nevertheless, they are visually balanced because the bird occupies much more area than the rock.

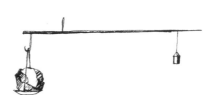

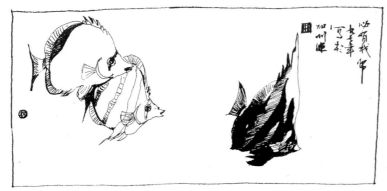

Color Balance

Color balance is based on color contrast. You can use warm color to balance cool color, and bright hues to balance dark hues. However, do not give the contrasting colors identical amounts of space. One color should be dominant. In this sketch, the two white fish on the left balance the black fish on the right. The contrasting perception of the colors achieves balance because black color is visually heavier than white.

Activity Balance

Active objects tend to occupy more space on a painting. Still objects, such as rocks and trees, are stable and require very little or no movement space. Here, the left side of this sketch has a large open area, but you do not feel it is really empty since the flying birds are moving toward it.

Line, Point and Surface Balance

Even though Chinese painting is mainly line art, points and surfaces are essential elements. A painting that has a combination and integration of these three elements carries more dramatic effect than a line-only painting because the elements balance each other. In the far left sketch, notice how the subject matter is drawn with lines only, lacking any attractive visual effects. But the manipulation of those lines, points and surfaces, as shown in the sketch on the right, creates a harmonic and beautiful impression.

Geometric Organization

It is common to group objects into a geometric shape, such as a circle, arc, triangle, rectangle or S-shape, in Chinese painting.

Though sometimes hidden when viewed up close, the geometric shapes reveal themselves if you view the paintings from a distance.

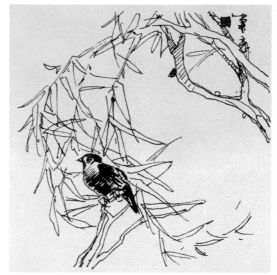

Circular Composition

A circular composition involves arranging objects and their activities in a circular structure. It tends to encourage motion of the objects and generate forces toward the center of a painting. The objects in these two sketches (left and below right) are arranged in circular shapes.

Arc-Shape Composition

An arc-shape composition places the objects in an arclike structure. The arc's angles can vary from composition to composition. It is a popular composition method since it is an easy way to organize objects. Paintings with arc-shape compositions have comfortable and relaxed visual effects. The first example shows an upward-curving arc that creates dynamic visual tension between the bird and the sunflower. The second example shows a downward-curving arc, emphasizing the bird on the top of the geometric shape.

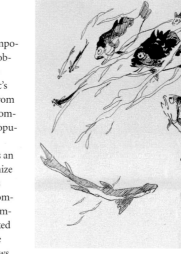

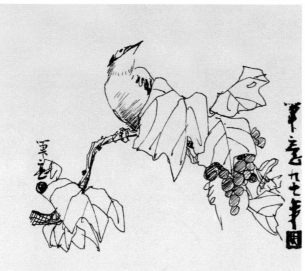

Triangular Composition

A triangular composition will give an impression of stability and inactivity if you place the objects as a pyramid near the center of the painting. On the other hand, this compositional method depicts dynamic motion if the objects are arranged in a tilted triangular shape. In the first example (left), the rock looks heavy and stable and the bird seems quiet. That is because of the pyramid-shaped composition. In the second composition (lower left), the koi form a tilted triangular shape that enhances the movement of the fish.

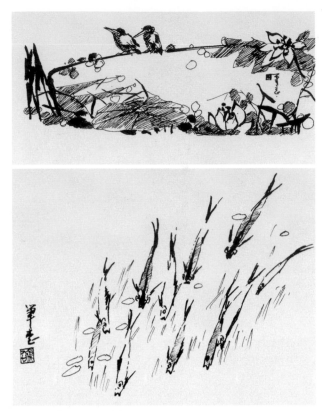

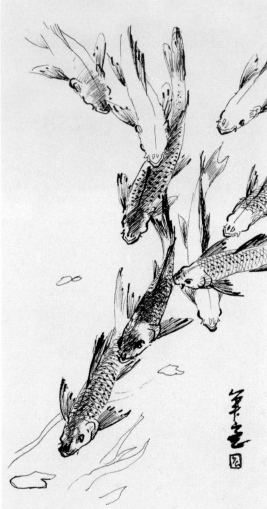

Rectangular Composition

Here objects are placed in a rectangular structure. The objects will appear relatively stable if the rectangle is placed in near alignment with the edges of the painting, as in the first example (above). In the second composition, however, the fish are arranged in a rectangular shape that tilts approximately 40° from the bottom edge of the sketch. The unstable placement of the rectangle further emphasizes the motion of the fish.

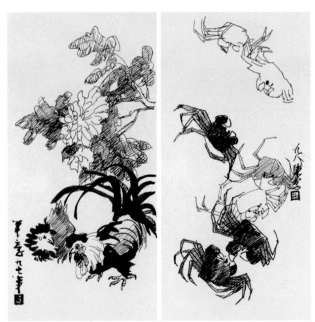

S-Shape Composition

Here objects are placed on an S-shaped path. It is a common composition in elongated paintings in which brief moments of dramatic activity are captured. In the first example, the rooster and hen seem to be communicating and interacting with each other. In the second example, the S-shape makes the normally slow-moving crabs appear more active.

Using Calligraphy and Chops to Balance the Composition

Before the Southern Sung dynasty (A.D. 1127–1279), artists did not inscribe poems or stamp their seals on paintings. Instead, they hid their signatures in the objects they painted. Inscription and sealing on paintings became favorable for three reasons. First was the development of the spontaneous scholar style. The artists of scholar style advocated the three perfections of calligraphy, poetry and painting. Second, artists left larger unpainted spaces on their paintings that were perfect for inscriptions and seals. Last and most important, artists inscribed phrases and poems to express their ideas, feelings and philosophies in relation to their paintings' images.

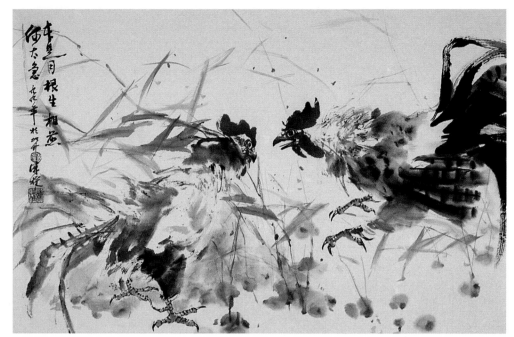

Balancing With Calligraphy

The calligraphy on the upper left balances the composition and expresses my idea. I quoted the last two lines of the famous *Seven-Step Poem* from the Three Kingdoms period, about 1,800 years ago. During this period, a king who was afraid his intelligent brother would try to take over the throne devised this plot against him. The king ordered his brother to chant a poem at the end of walking seven steps. If the brother could not finish on time, the king would kill him. At the final step, his brother chanted the poem:

> Grinding beans for juice,
> To make meat and bean soup.
> Burning the bean shells and their stems,
> While the beans in the pot are cooked.
> Coming from the same root,
> Why do they destroy each other so rude?

Thus the painting is not only art but also an assertion of my point of view on humanity.

TWO FIGHTING ROOSTERS
18" x 27" (46cm x 69cm)
Chinese ink and colors on single-layer Shuan paper
Spontaneous style

Breaking the Lines

If you draw lines through each group of objects in a Chinese painting, you will see they cross each other. One of the lines represents the primary force and direction of eye flow in the painting. The others indicate minor forces and secondary objects. The quantity of the lines is usually an odd number. Most of the minor lines break and integrate with the major line to create interesting composition.

In each of the sketches on this page, a broader line represents a major object, with an arrow indicating the force and direction of flow. The narrower lines represent minor objects.

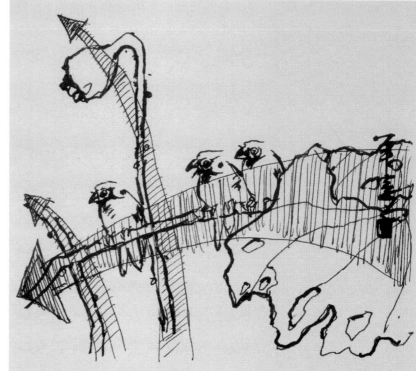

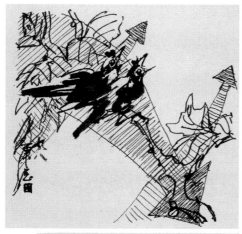

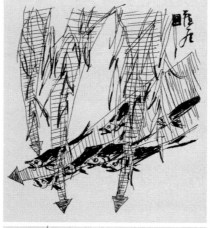

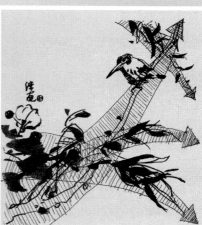

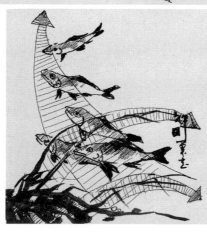

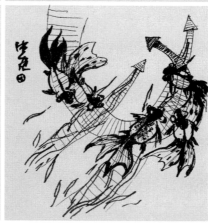

DETAIL-STYLE PAINTING TECHNIQUES

Generally, artists begin detail-style paintings by using light ink to outline objects in a controlled manner. Detail-style painting also takes a much longer time to finish than the spontaneous style. The following are the basic techniques and sequences of detail-style painting. Though each step comes from a different painting, each represents a critical stage in a typical detail-style painting.

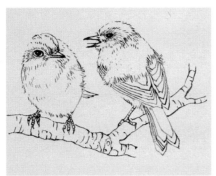

1 PAINT FIRST OUTLINE

Use small, pointed hard-fur brushes to paint the outlines of the objects. Hold the brush at the center-brush angle to paint fluid, elastic and confident strokes. Outline the eyes, beaks and legs with intense ink and the rest with light ink. Paint the brushstrokes according to the feathers' growth directions.

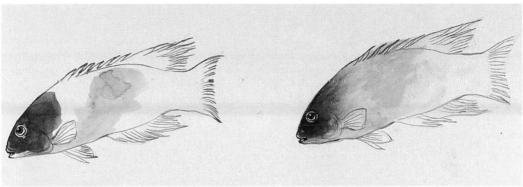

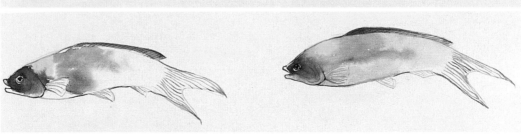

2 ADD FIRST LAYER OF COLOR

After you have finished the first outline process, use light ink and colors to fill in spaces between the outlines as the first layer of coloring. There are two ways to apply the ink and colors. Using the first way, *dry coloring* (left), apply the ink and colors to a dry area and use clear water to drag and blend them within the outlines. This is similar to watercolor's wet-into-dry technique. For the second method, *wet coloring* (right), wet the area between the outlines before applying the ink and colors. This is similar to watercolor's wet-into-wet technique. Soft-fur brushes are commonly used for coloring.

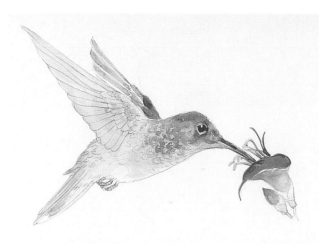

3 *Add multiple layers of color*

Add multiple layers of colors on an object in order to get the appropriate intensity and textures. When the first layer of color dries, apply a second layer of color and continue the same process again and again until the desired effects are achieved. I usually apply the ink and colors at least three times. Amazingly, it does not make the paintings dirty as easily as in watercolor. As you can see at left, the first layer of color does not reach the desired intensity. But after multiple layers of color, as shown in the middle painting, everything becomes vibrant and alive.

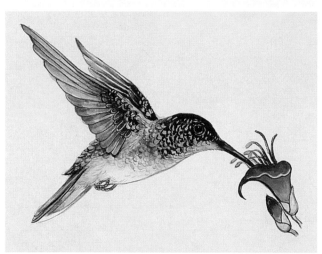

4 *Outline again*

Some outlines will partly disappear after applying colors, as shown in the top bird (at left). Paint those outlines again on top of the first outlines with ink and color, as shown in the bottom bird. Use colors that are more intense than the colors painted on the objects. For example, if you paint a tail yellow, use orange combined with light ink for the second outlines. Likewise, if you paint the fish scales red, mix Rouge with intense ink.

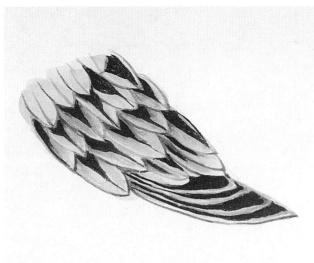

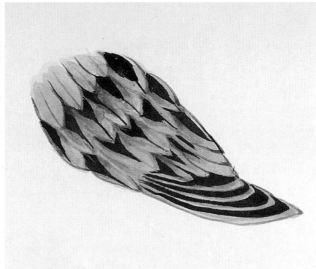

5 *Glaze*

Adding one or several layers of colors over a large painted area, such as the feathers of wings, is called *glazing*. It serves the purpose of uniting a variety of colors. Some Chinese colors are transparent if you apply them as thin layers. Among them are yellow, red, Carmine, Indigo and light ink. The wing on the left is before glazing, while the other wing (right) shows the effects of glazing with a thin layer of Cinnabar.

6 *Leave white edges*

Leave white edges to define small details. For example, when painting fish and birds, leave a narrow white line on the edge of each scale and feather. Then apply less intense colors or ink on the white lines to define the scales and feathers clearly.

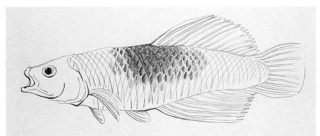

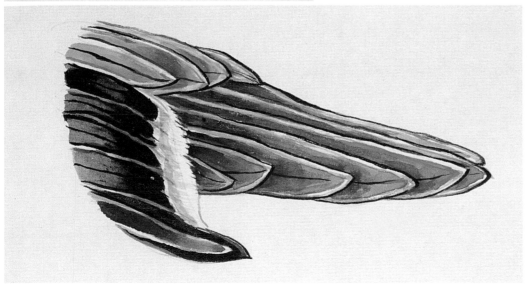

Creating Feather and Fin Textures

There are two methods you can use to create bird feathers and fish fins. The first way is to use a small, pointed brush to paint each feather or fin carefully according to its growth direction. Another way is to form the tip of a used brush into a loose shape and then paint in overlapping strokes to suggest detail.

Method 1
Use a small hard-fur brush and ink to illustrate each feather. Then apply colors over the strokes.

Method 2
Use the loose-tipped brush and ink to paint groups of strokes overlapping each other. Next, apply colors over the strokes.

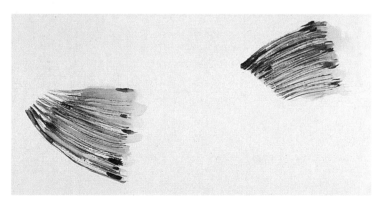

Combining Methods 1 and 2
Use the small hard-fur brush to paint individual strokes, creating the texture of the fins. Then use the loose-tipped brush to paint over the individual strokes. Finally, paint colors on top of the strokes.

BALD EAGLE IN DETAIL STYLE

This four-step bald eagle painting demonstration will provide you with a better understanding of the techniques and process of detail-style paintings.

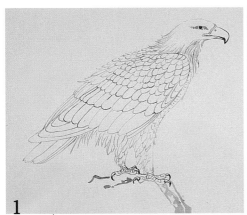

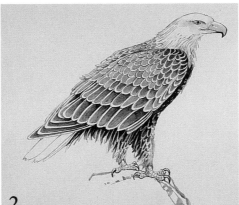

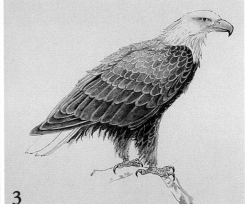

1 PAINT FIRST OUTLINE

Use a small hard-fur brush. Paint the outlines with light ink except for the beak, eye and claws, which should be painted with intense ink.

2 ADD BASE COLOR

Apply ink as base color to define the volumes and shapes of body parts and each feather. First, use light ink and the dry-coloring method to paint the eagle. Define each feather by carefully leaving white edges. When the first layer of ink is dry, apply more intense ink on top of the first layer. To paint the gradations on each feather, use a small hard-fur brush to place intense ink at one end of the individual feather, then use a small soft-fur brush and water to drag the ink toward the other end.

3 ADD SECOND COLOR

Use a medium soft-fur brush to paint Gamboge (yellow) and Vermilion on the beak and claws, and Rouge and Gamboge on the feathers.

4 APPLY MULTIPLE COLORS, GLAZES, SECOND OUTLINES AND DETAILS

When the colors dry, repeat the process at least three times until the colors have reached the desired intensity: strong enough to show the textures, yet not muddy. Next, use a large soft-fur brush to apply a thin layer of Indigo on top of the feather area as glazing. Use a similar brush to paint light Indigo and ink on the background around the neck and tail so that the white colors of the paper will stand out. Finally, paint the second outlines and details with a small hard-fur brush.

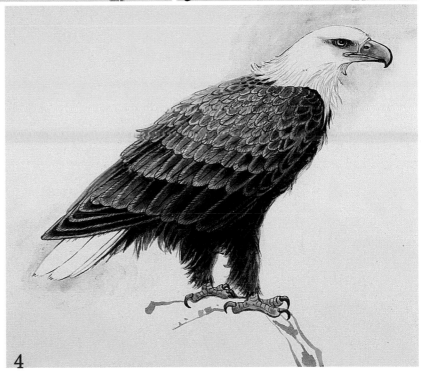

SPONTANEOUS-STYLE PAINTING TECHNIQUES

Unlike detail style, which uses vivid colors, spontaneous style uses ink as its primary media. In fact, some artists painted only with ink. Their paintings are called *water-ink painting*. The manipulation of brushstrokes in spontaneous style is similar to that in calligraphy to the extent that artists use the term *writing* to describe painting.

Simplicity is the key word here. Often, objects in the paintings are simplified into minimal brushstrokes with limited colors. The theory of simplicity comes from Taoist and Buddhist beliefs. They state that simple is beautiful. Consequently, simplicity has become an important aesthetic standard in Chinese painting, especially in the spontaneous style.

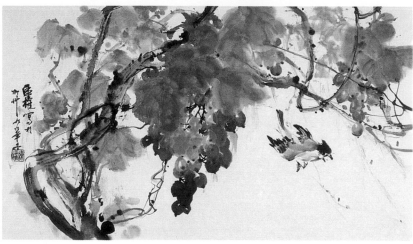

Using Colors in the Spontaneous Style

This painting does not render small details. Instead, it depicts the spirits and essence of the objects with sure, passionate and free strokes similar to calligraphy.
GRAPES AND A
FLYING BIRD
16" x 27"
(41cm x 69cm)
Chinese ink and colors on single-layer Shuan paper
Spontaneous style

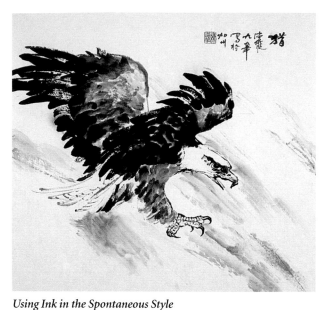

Keeping Things Simple

This is a good example of the simplicity seen in spontaneous-style paintings. Every stroke is taken into consideration in creating the texture, movement and formation of the objects.
CRABS AND SHRIMP
18" x 22"
(46cm x 56cm)
Chinese ink on single-layer Shuan paper
Spontaneous style

Using Ink in the Spontaneous Style

Water-ink paintings are usually painted in spontaneous style. Artists rely on brushstrokes and different tones of the ink to depict objects.
EAGLE
20" x 27" (51cm x 69cm)
Chinese ink on single-layer Shuan paper
Spontaneous style

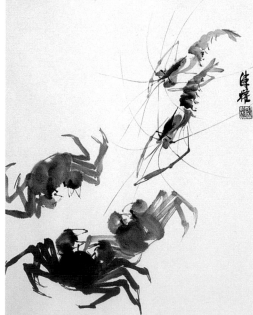

FISH IN SPONTANEOUS STYLE

In contrast to detail style's set painting process, spontaneous style makes use of a variety of methods and steps. Let's paint some fish as an exercise in learning techniques and the common steps of spontaneous-style painting.

1 ORGANIZE THE COMPOSITION
Spend a few minutes arranging this composition in your head before sketching it on rice paper.

2 MAKE A ROUGH SKETCH
Once you have your composition in mind, start sketching the main outlines of the front fish on Shuan paper. Use a small medium-fur brush and ink. This step will establish the basic shape of the fish. Sometimes artists do not sketch at all before painting; they adjust the images according to the results during the painting process.

3 PAINT THE MAJOR ELEMENTS AND THE FOCUS AREA IN OUTLINE
Use a midsize hard-fur brush with ink to paint the mouth, gill, fins and tail. Use a midsize soft-fur brush to paint the upper and lower parts of the mouth and the outline of the eye. The brushstrokes should suggest textures and forms. The stroke for the front gill is broader on the bottom and narrower toward the head. It suggests the motions of the gill, which opens wider on the bottom and narrower at the top.

4 ADD COLOR
Next, use a large soft-fur brush to apply colors on the head and gill area using the center-brush method, which will create soft textures. Fill the brush with water and yellow color. Mix it with Vermilion until half of the brush has both colors. Use the tip of the brush to add a little Rouge. Now the brush has three color zones: yellow, yellow and Vermilion, Vermilion and Rouge. Now each stroke created by the brush will have color gradations. Apply the colors on the head area.

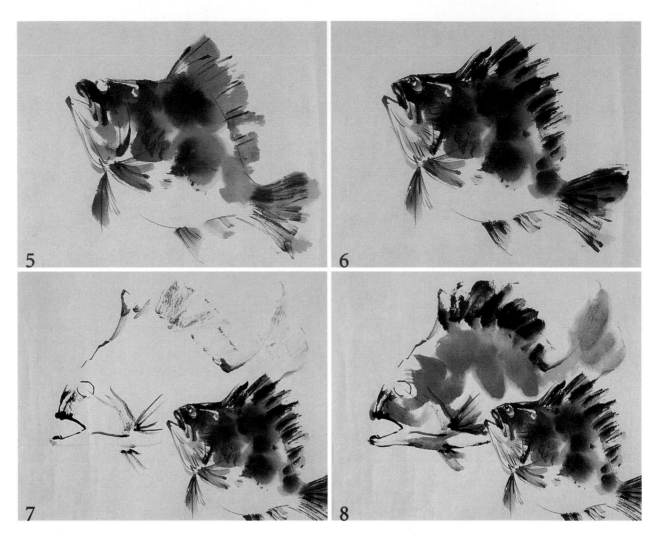

5 Paint less-important areas

Use the side-brush method to paint the fins and tail with the same colors used in step four. (Soak the brush with one color, then add another color up to the middle. Next, pick up one more color with the brush tip. This will allow you to create multiple colors with one stroke.) While the colors are wet, use the same brush to get intense Rouge and mix it with ink on the tip of the brush. Paint on top of the colored areas on the body and tail to create dark red spots.

6 Further define textures and details

While the colors are wet, use a midsize hard-fur brush, intense ink and the side-brush method to further define textures of the fins and tail. When almost dry, use intense ink to add more details to the head, gill and mouth. Finally, use a small medium-fur brush to complete the eye.

7 Paint the outlines of the second fish

Use a medium hard-fur brush and ink to paint the outlines of the second fish. Paint the mouth and outlines of the tail using the center-brush method. Paint the fins and the gill with the side-brush method.

8 Add color to the second fish

Wet the large soft-fur brush water and get some yellow. Mix the yellow with Vermilion to paint the body using the center-brush method. Immediately use the tip to get some blue to paint the fins, tail and upper part of the body. While the colors are wet, use a large hard-fur brush with intense ink to paint the fins using the side-brush method.

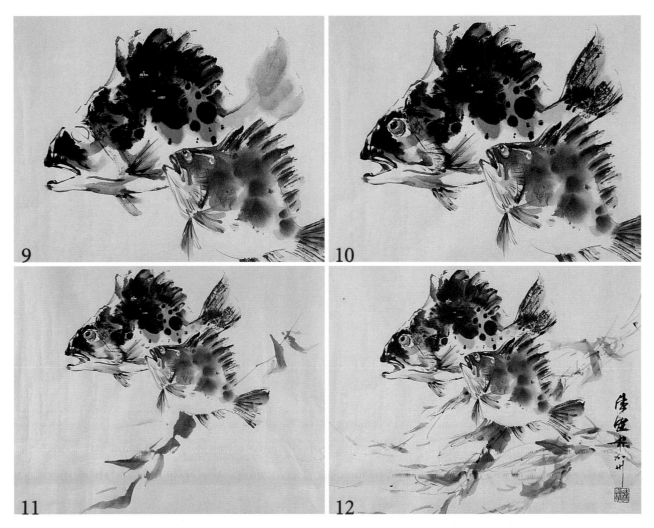

9 ADD DETAILS TO THE SECOND FISH

Continue to paint the dark spots on the fish body with the same brush and intense ink. Define the area on the eye and mouth when the colors are almost dry.

10 ADD DETAILS TO THE GILLS

Use the same brush with ink to define details on the gill. Next, use the coloring brush and a very small amount of Rouge on its tip to paint the eyeball. Finally, use a small hard-fur brush with very intense ink to paint the pupil, leaving a tiny white area as its reflection.

11 PAINT THE BACKGROUND

To emphasize the motions of the fish, take a large soft-fur brush and paint the leaves of the seaweed using the side-brush method. Use the brush to mix Indigo with yellow and ink. Paint various-sized strokes to represent different sizes of leaves.

12 SIGN AND SEAL

When the colors are still wet, use a medium hard-fur brush and intense ink to paint the veins of the leaves. Finally, sign the painting with intense ink and stamp your chop on it.

TWO BODIES
17" x 17" (43cm x 43cm)
Chinese ink and colors on single-layer Shuan paper
Spontaneous style

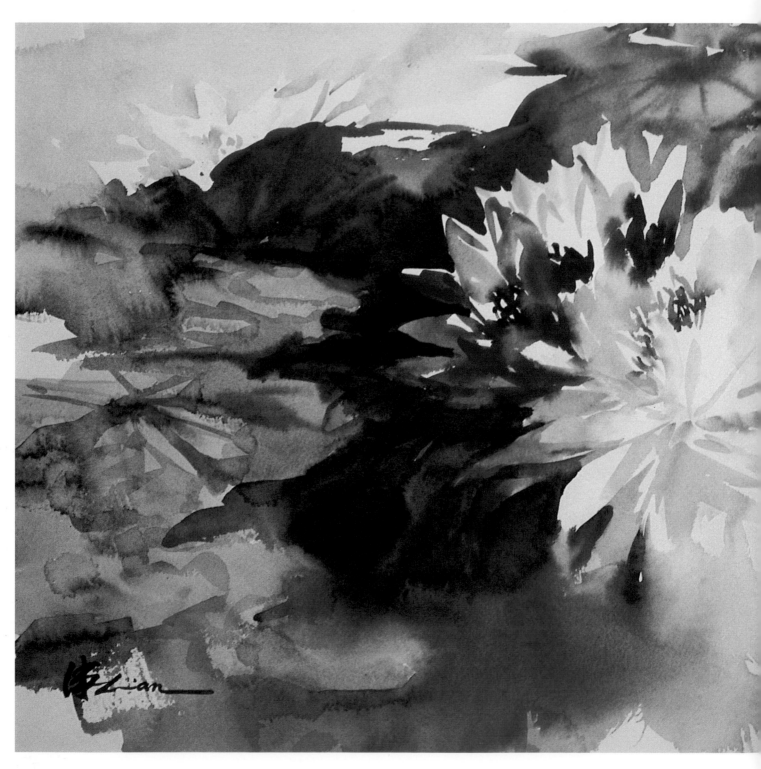

WATER LILY
14" x 21" (36cm x 53cm)
Chinese ink and colors on double-layer Shuan paper
Spontaneous style

FROM CHINESE PAINTING TO WATERCOLOR

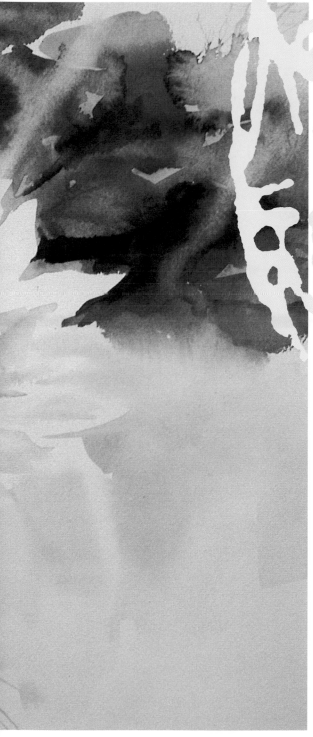

3

Once during a watercolor demonstration, a student asked me whether I was creating a watercolor or Chinese painting. Obviously, my watercolor is strongly influenced by Chinese painting, to the extent that I unconsciously integrate Chinese painting techniques and theories with watercolor painting. I do not think it is important to differentiate a painting style, but it is essential to create paintings from the heart and soul. Colors, brushes and papers are only tools, which we use to express our true selves.

When I was in China, I mainly painted Chinese paintings. After I moved to the United States, I learned to love painting with watercolors. To me, it's the closest medium to Chinese painting in materials, techniques and theories. Having a background in Chinese painting helped me master watercolor.

MY EXPERIMENTS AND THEORIES
ON WATERCOLOR PAINTING

Educated in both Eastern and Western arts, I have my own points of view on watercolor. They are not necessarily the same as other artists'.

Ink-Pouring Influences on My Watercolor

Ten years ago, I started *color pouring and blending,* a method derived from ink pouring. With the help of masking fluid, pouring three primary colors on watercolor paper and directing their blending can create magnificent effects. Such dreamy, harmonic and powerful expression is what I have long been searching for in my paintings.

I have two different ways of painting with color-pouring-and-blending techniques. The first way starts with applying masking fluid on large areas that I want to preserve for details, then pouring the colors. The second starts with painting the objects, then pouring the colors to paint the background.

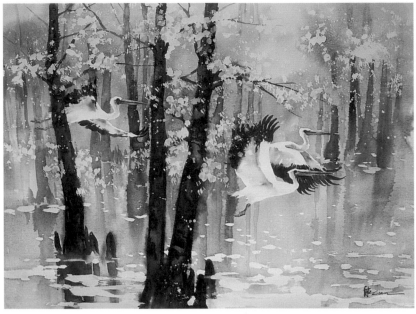

Color-Pouring-and-Blending Technique
Use masking fluid to block out the birds, tree leaves and water highlights. Wait for the masking fluid to dry. Pour the three primary colors to paint the water, the tree trunks and the background. When the colors dry, lift the masking fluid and paint the details of the egrets, tree and water highlights.
THREE PELICANS
21" x 29" (53cm x 74cm)
Watercolor on Arches 140-lb. (300gsm) cold-press watercolor paper
Color pouring and blending

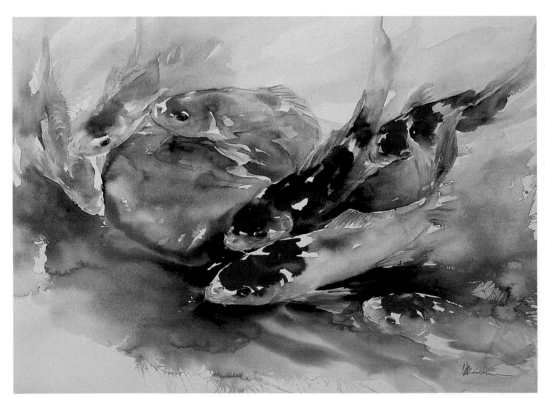

Color-Pouring-and-Blending Technique
Apply masking fluid only on the fish eyes before painting. When the masking fluid is dry, paint the koi. Then pour the three primary colors around the fish to paint the water. The whites on the koi bodies are unpainted areas.
KOI
21" x 29" (53cm x 74cm)
Watercolor on Arches 140-lb. (300gsm) cold-press watercolor paper
Color pouring and blending

Three Colors—Enough to Create a Beautiful World

Most of the time, I paint with the three primary colors. Almost all watercolor paintings and demonstrations in this book are from the primary colors. My workshop students are surprised that I have only a few colors and brushes in a little box. In fact, many of my students bring more colors to my classes than I do. After my workshop, they are happy to know that they do not need to spend a lot of money on colors.

There are several reasons for limiting the colors used. First, I love the Taoist and Buddhist idea of simplicity. It is one of the most important goals that many famous artists have attempted to achieve in both Eastern and Western cultures. The legendary modern Chinese painting master Chi Bai Shi painted with limited strokes and colors. His shrimp and crab paintings, for example, use minimum strokes that capture the spirits of the objects. Similarly, Picasso once spent several months sketching a cow. He started with detail sketching and gradually dropped the details. At the end, he simplified his sketch with a few lines to depict the cow. Interestingly, children's artwork is also very simple. They tend to focus on the major features of objects.

Second, mixing three primary colors allows me to create other pigments that relate to the original pigments. Watercolors have amazing blending effects. I let them mix freely on watercolor paper with only minor adjustments. It creates magnificent colors. In addition, I also mix them using traditional watercolor painting techniques. As a result, I am able to get most of the colors I want.

For this book's watercolor demonstrations, *mixing* yellow, blue and a little red means to use a moist brush to pick up the colors and mix them on your palette. This will create one-color strokes. When I say to *get* yellow, blue and a little red, it means to fill a moist brush with yellow first, then blue up to its middle and finally red on its tip. This method will result in three-color strokes, since the colors will not completely mix before being placed on the paper.

Children's Art 1
My daughter drew this when she was eight. I am amazed by its simplicity and clarity—it uses only a few lines to depict the most important characteristics of the fish.
ORCA WHALE AND BUTTERFLY FISH
9" x 11" (23cm x 28cm)
By Amery Zhen
Black markers on sketch paper

Children's Art 2
I do not know what kind of bird she sketched. It seems that she did not care about that. Again, she used minimum lines and colors to paint a lively bird.
BIRD
7" x 8"
(18cm x 20cm)
By Amery Zhen
Color markers on sketch paper

Endless Variety
Here is a sample of the variety of colors that can be acquired from pouring the three primary watercolors next to each other.

Color is not the only essential element in watercolor painting. Brushstrokes and composition are also important.

I refuse to be dictated by objects' real colors. I like to create my own color schemes from my impressions. When I paint colorful goldfish, for example, I do not copy actual colors on each fish from what I have seen. I endeavor to capture an overall impression of their colors. Therefore, I paint from either my memory or a few glances. I want to create my own fish. I believe depicting a real fish is a camera's job. People call some of the goldfish on my paintings "Lian's goldfish" because they do not find the same species elsewhere.

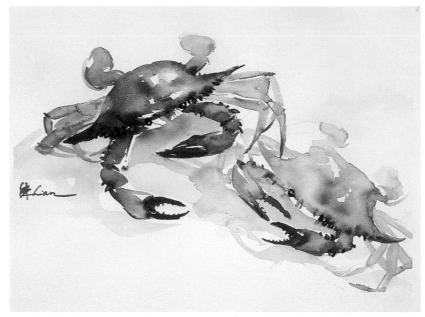

Essence of Brushstrokes
Brushstrokes play a big role in depicting objects' textures and motions in this painting. Those brushstrokes are most obviously shown on the legs and claws.
TWO CRABS
10" x 15" (25cm x 38cm)
Watercolor on Arches 140-lb. (300gsm) cold-press watercolor paper
Color pouring and blending

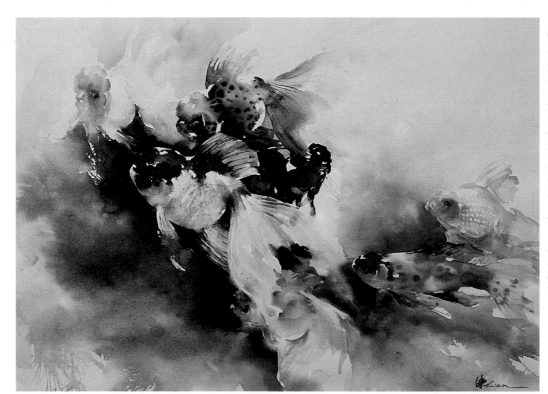

My Goldfish
The colors of the three goldfish in this painting are my creation. They are the red-crown on the bottom and the black-red and the black-spot behind the center large goldfish.
GOLDFISH
21" x 29"
(53cm x 74cm)
Watercolor on Arches 140-lb. (300gsm) cold-press watercolor paper
Color pouring and blending

Free Lighting

Traditionally, light is not a major element in Chinese painting, since Chinese painting focuses on depicting objects' shapes rather than their three dimensions. Artists ignore unnecessary details, such as highlights and gradations, and use alternative methods to suggest light effects. Depicting a night scene, for instance, they paint a moon on the sky as an allusion to night, instead of painting a dark sky.

In combining both Chinese and Western lighting effects, I have created my own style I refer to as *free lighting*. When painting a fish, for example, I do not carefully define its highlight, shadow and reflection areas; rather, I leave white on its head and body randomly to suggest its volume and lighting effects. The highlights could be on the upper part of the fish's head and body, as well as on the middle and lower parts. As a result, there are multiple light sources.

In addition, I do not always paint shadows nor follow the lighting directions to paint them. I only consider painting shadows when they are critical in defining volume and composition. Otherwise, I use background to function as shadows.

From time to time, I also try to capture diffuse lighting and backlighting effects. Objects under diffuse lighting situations do not have strong shadows. They appear soft because the lights illuminate from different directions. Diffusing lights create a warm, lovely and dreamy environment. Similarly, backlighting gives a profound and spiritual impression. Nature does not control me, yet I want to re-create it in my paintings.

Free Lighting, Example 1
The highlights on the camerons' bodies are kept white between the minimal strokes. The other unpainted areas represent water. Even though there is no sky, light beams or shadows, viewers can feel the bright environment.
THREE CAMERONS
15" x 22" (38cm x 56cm)
Chinese ink on single-layer Shuan paper
Spontaneous style

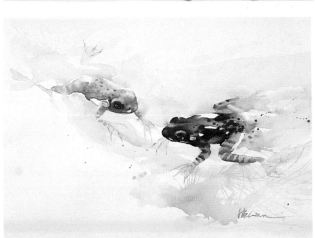

Free Lighting, Example 2
There are multiple light sources in this painting. The highlights on the backs of the frogs indicate a light source coming from the top, while the highlights on the mouths suggest another light source at bottom. In addition, the highlight on the left leg of the frog at right is from a light source at right. Shadow is not necessary because the water helps to define the volume of the frogs.
TWO FROGS
10" x 14" (25cm x 36cm)
Watercolor on Arches 140-lb. (300gsm) cold-press watercolor paper
Color pouring and blending

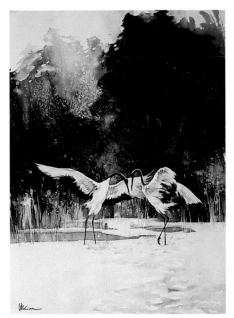

Combination of Diffused Lighting and Backlighting
This scene has soft backlighting. Also, it has diffused lighting effects because the snow strongly reflects the lights. Therefore, I did not paint strong shadows.
LOVE DANCING
21" x 29" (53cm x 74cm)
Watercolor on Arches 140-lb. (300gsm) cold-press watercolor paper
Color pouring and blending

No Mistakes

"No mistakes" is an optimistic attitude that allows me to release the pressures of forcing myself to create a masterpiece every time I paint. It does not mean I do not make mistakes during painting; it is my attitude toward the mistakes. When I make mistakes, I try to turn them into creations.

In my workshops and classes, I have seen students so upset about their paintings that they lose their interest in learning. Painting is supposed to be fun, not stressful and boring. Taoism advocates a belief that everything in the universe has a purpose and is natural. I think making mistakes while painting is natural.

When to Stop

When to stop is a tough question to answer. Some artists tend to over-paint because they are searching for realistic and perfect representations. I am no exception.

Take a look at the examples on this page. I had planned to use this hummingbird painting as a demonstration in this book. Starting from the beginning, I took pictures to record the painting process. Toward the end of painting, I realized that I had overworked the bird in the upper right corner.

If you do not know when is the best time to stop, take pictures to record your painting process, then analyze them. Most likely, you will realize that you should have stopped just a few steps before taking the last picture.

Another way to learn when to stop is to review watercolor demonstrations in books and magazines. Be critical and analytical. Even master watercolorists may not stop at the right moment. As an outsider, you can easily tell when to stop and will learn from their experiences.

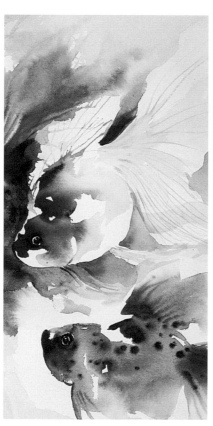

A Mistake With a Happy Result
During the painting process, I blow the colors on the background to direct their flowing and mixing. Here, my blowing was so strong that some colors spilled over into the dorsal fin of the goldfish. It was not the result I wanted, yet it looked like the texture of the fin. Also, it suggested the motions of the fish. Therefore, I kept the colors.

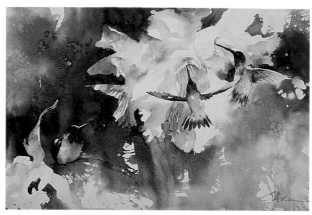

Best Time to Stop Painting
I took this picture several minutes before the bird was over-painted. It was the best time to stop.
THREE HUMMINGBIRDS AND LILY FLOWERS
14" x 20" (36cm x 51cm)
Watercolor on Arches 140-lb. (300gsm) cold-press watercolor paper
Color pouring and blending

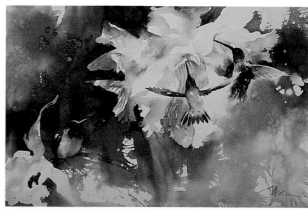

Overworked Painting
This picture shows the overworked bird on the upper right corner.
THREE HUMMINGBIRDS AND LILY FLOWERS
14" x 20" (36cm x 51cm)
Watercolor on Arches 140-lb. (300gsm) cold-press watercolor paper
Color pouring and blending

VARYING THE COMPOSITION

My watercolor painting composition is the integration of Chinese painting's free organization and Western art's perspective theory. When I arrange objects in my painting, I use whatever methods and theories meet my needs.

Perspective

Perspective in my watercolor is free and loose, especially in bird and fish paintings. I have done architectural renderings in college and at work. The renderings have to be so perfect in per-

spective that they look dry and mechanical. It is not the effect I want my paintings to have. I want my paintings to be free and creative. To achieve my goal, I free myself from accurate perspective.

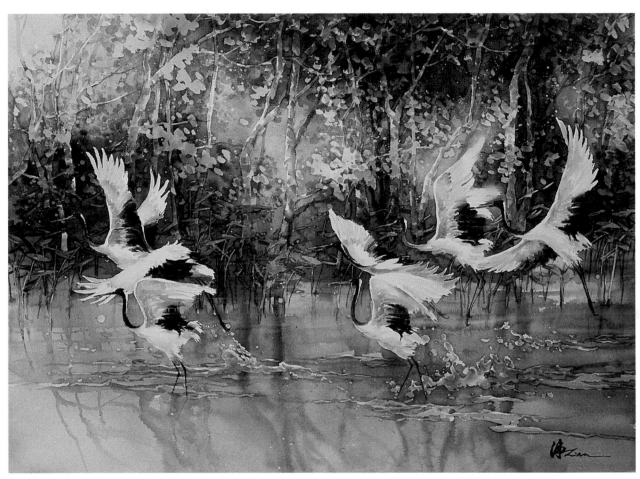

Linear Perspective
This is a linear or moving perspective painting. The trees and weeds are placed horizontally in the background without concentration on perspective. It emphasizes the crane's flying motion. Also, the cranes are arranged with individually defined perspectives.

MORNING FLY
21" x 29" (53cm x 74cm)
Watercolor on Arches 140-lb. (300gsm) cold-press watercolor paper
Color pouring and blending

Geometric Structure

As I do in my Chinese paintings, I group objects in geometric structures in my watercolor compositions. Let us take three paintings as examples. The first painting is *Three Angels,* a painting of three angelfish with different colors. I arranged their bodies together on an arc-shaped path that helps to further emphasize their motion. The angle of the arc could be narrower or wider. However, if it becomes too close to a horizontal line, the painting will lose its dynamic effect.

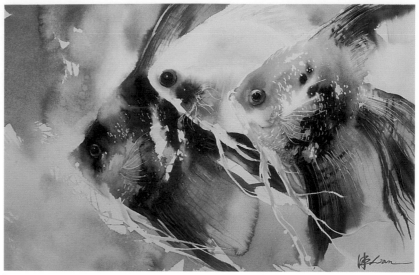

Arc-Shape Composition
Imagine a line drawn through the fish eyes to the tail of the yellow fish at front.

THREE ANGELS
15" x 21" (38cm x 53cm)
Watercolor on Arches 140-lb. (300gsm) cold-press watercolor paper
Color pouring and blending

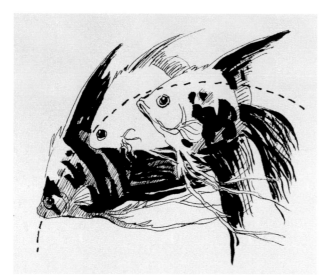

Same Fish Placed on a Narrower Arc
A narrower arc creates a stronger motion effect.

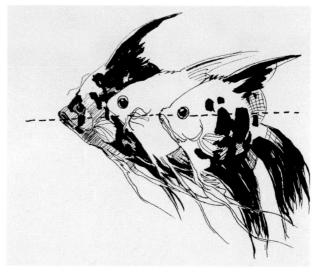

Same Fish Placed on a Wide-Open Arc
A wide-open arc resembles a horizontal line. In this composition, the fish are not in dynamic motion.

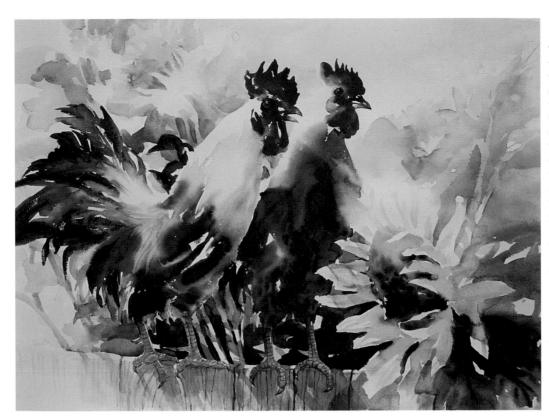

Triangular Composition

This painting has a triangular composition. The two heads of the roosters form the top angle, while the tails on the left and the sunflower on the right are the two other angles. Since the triangular shape is like a pyramid near the center of the painting, it provides a sense of stability to the roosters that are standing on the wooden fence. If I move the sunflower from bottom right to middle right, the triangular composition will disappear. The roosters and the sunflower would be too close together.

ROOSTER AND SUNFLOWERS
21" x 29"
(53cm x 74cm)
Watercolor on Arches
140-lb. (300gsm)
cold-press water-
color paper
Color pouring and
blending

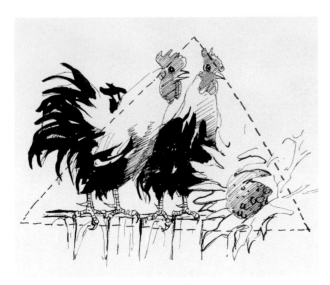

This sketch shows the triangular composition.

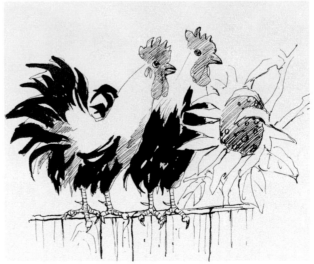

Without the triangular structure, the objects lack vitality.

Three Ways to Compose Geometrically

Using geometric structures is a simple and easy method for organizing compositions. There are three ways to make composition sketches using geometric shapes: Arrange objects on a path, arrange objects within one shape or arrange objects within multiple shapes.

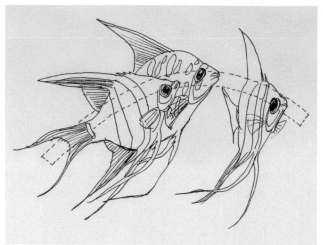

Method 1: Arrange Objects on a Path of a Geometric Shape

Start by drawing a geometric shape, such as an arc or a circle. Then place major objects on the path of the shape. The fish shown here are arranged on the paths of different arc shapes.

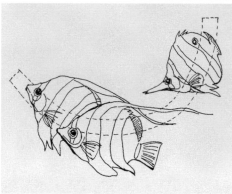

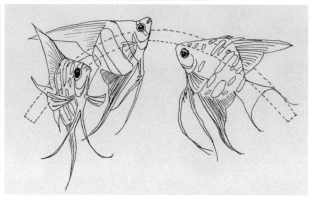

Method 2: Arrange Objects Within One Geometric Shape

Sketch a geometric shape first, then organize objects within the shape. This is handy for a composition having two or three major objects. The goldfish shown here are in the oval shapes.

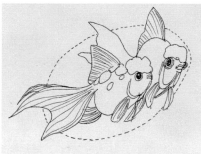

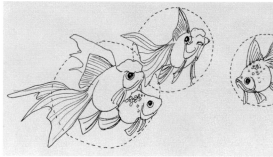

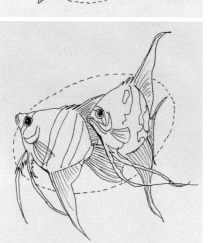

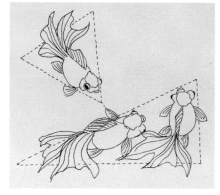

Method 3: Arrange Objects Within Multiple Geometric Shapes

Sketch two or more geometric shapes at the beginning. The shapes can be the same or different. Next, organize objects within the shapes. It is common to place the major objects in the large shape and minor objects in the small shapes. I use this method for paintings with three or more objects.

Leaving White for Balance

One similarity between Chinese painting and watercolor is leaving some areas of each painting white, unpainted. In watercolor, the unpainted areas can serve the purpose of balancing composition and highlighting. In addition, they are the spaces for viewers to input their ideas and imaginations. The viewers will "finish" the paintings.

I think a painting with proper unpainted areas is comparable to the ruins of the Colosseum in Rome. Both of them are physically incomplete yet more attractive and beautiful because of this. Their incompleteness piques curiosity and imagination.

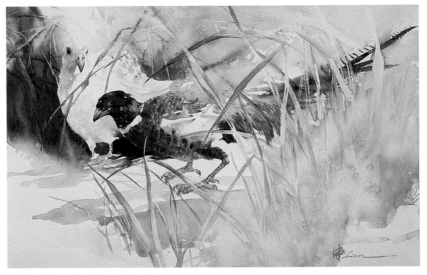

Leaving White Areas, Example 1
The white areas on this painting provide strong contrasting effects between the colorful bird in front and the white bird behind, and between the intense background and the white bird. The whites also provide balance between the colors. In addition, the whites on the body of the front bird suggest shape and highlights.
TWO PHEASANTS
14" x 21" (36cm x 53cm)
Watercolor on Arches 140-lb. (300gsm) cold-press watercolor paper
Color pouring and blending

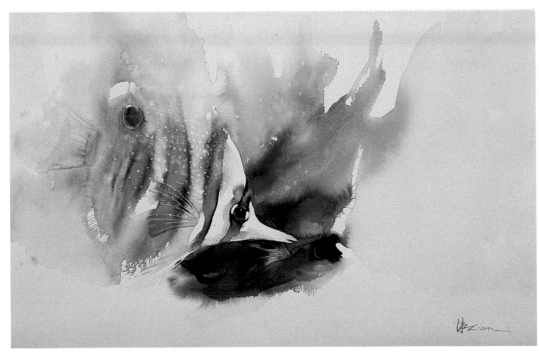

Leaving White Areas, Example 2
There are a lot of unpainted areas on this painting. They contrast and balance the dark color of the fish. The whites on the fish suggest not only highlights but also the shapes of the fish.
TWO BUTTERFLY FISH
14" x 21" (36cm x 53cm)
Watercolor on Arches 140-lb. (300gsm) cold-press watercolor paper
Color pouring and blending

Focal Point

When people talk to each other, they usually look at each other's eyes. The eyes become the focal points in the action. Similarly, a painting has one or a few *focal points*. They are larger primary objects painted with more details, brighter colors and dramatic gestures. Even though there may be only two fish or birds in a painting, one of them should be more outstanding. A painting without a focal point resembles a person talking without a topic.

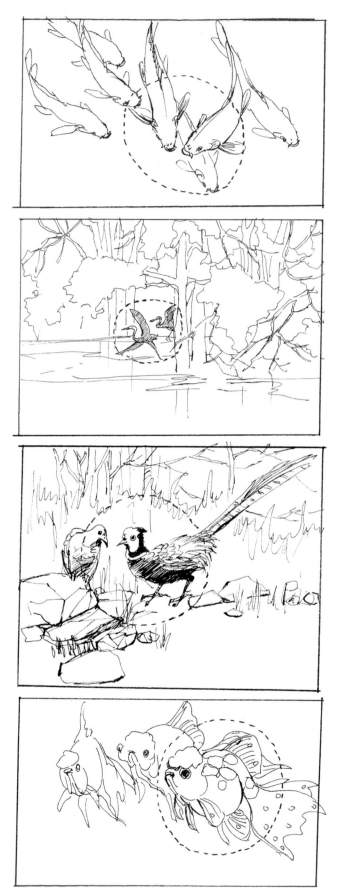

The dotted circles on these sketches represent the focal points of each composition.

Placing Your Signature

Some artists sign their paintings for authenticity purposes. Their signatures do not help to improve their paintings and are at worst distracting. I consider my signature as part of the whole composition, and it should blend with the colors and brushstrokes. My signature for watercolor paintings is my first name in Chinese and English. Often, I sign it near a bottom corner depending on the compositional balance.

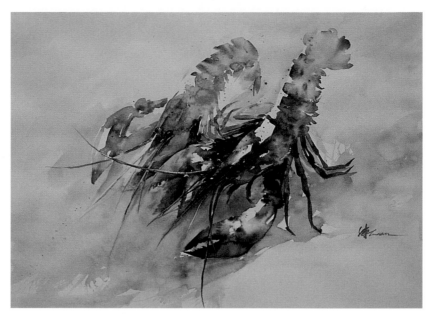

Minimizing a Signature's Impact on a Painting

The lobsters are moving toward the left, leaving an empty space on the right. Thus I signed my name on the lower right corner. The signature is next to a leg, as if an extension of it. As a result, it does not carry away the tensions from the lobsters.

TWO LOBSTERS
21" x 29" (53cm x 74cm)
Watercolor on Arches 140-lb. (300gsm)
cold-press watercolor paper
Color pouring and blending

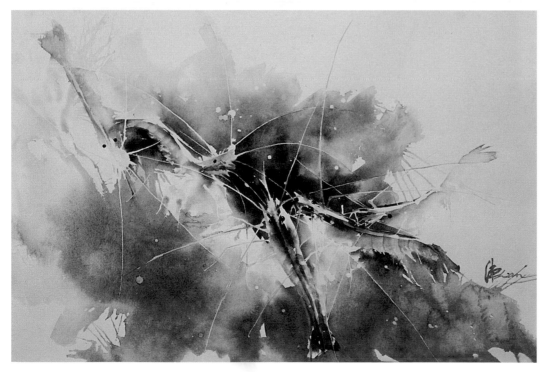

Integrating Your Signature Into the Painting

I follow the background strokes and colors to sign my name. It becomes part of the painting.

SHRIMP
14" x 21"
(36cm x 53cm)
Watercolor on Arches 140-lb. (300gsm) cold-press watercolor paper
Color pouring and blending

SPECIAL MATERIALS FOR WATERCOLOR

I use common watercolor materials you can find in major art supply stores. I believe that having more and complicated materials is not necessary to make my paintings look better. Some materials can create special effects, such as salt used to produce rain and snow impressions. However, I do not want to over-manipulate such materials because they can overshadow my personal style.

Papers

I used Arches 140-lb. (300gsm) cold-press watercolor paper for all watercolor paintings and demonstrations in this book. I always buy full sheets in packs. When I want to paint smaller paintings, I cut the sheets into the desired size.

Occasionally, I use heavy paper, such as Arches 300-lb. (640gsm) paper. If you are a beginner, I suggest you try different kinds of papers. You will find one that you like best.

Brushes

I use flat and round sable brushes. Their sizes range from small to large. The flat brushes, for example, range from ⅛-inch to 2-inch (3mm to 51mm). The round brushes are from no. 4 to no. 10.

Paints

The three primary colors I use are Cadmium Red Deep from Winsor & Newton and Ultramarine Blue and Cadmium Yellow Light from Utrecht.

Occasionally, I use other colors, such as Violet, Cadmium Yellow Deep and Cobalt Blue. Colors from different manufacturers may be slightly different despite having the same name.

Palette

I use a John Pike palette for indoor paintings and a smaller palette for outdoor sketches. Often, I put one pigment in two compartments on a palette. One compartment is for mixing and the other is for pure coloring. It's nice to arrange colors from warm to cold or vice versa so that it's easier to keep them clean when mixing.

Arranged Colors on My Palette
This is my color layout on a John Pike palette. Warm colors are on the left and cool colors are on the right. Each color occupies two compartments.

Masking Fluid

Masking fluid is necessary for painting with the color-pouring-and-blending technique. I use Winsor & Newton light yellow Art Masking Fluid, but since the yellow fluid doesn't show clearly on slides, I used a pink masking fluid from another manufacturer for the demonstrations in this book.

When a bottle of masking fluid is more than half used, it gets thick. Put half or one capful of clear water into the bottle to dilute the fluid.

Incredible Nib and Bamboo Pen

The Incredible Nib looks like a pen with a nib at each end. It is used to apply masking fluid to small areas. Bamboo pens are also good for the same purpose. In one of my watercolor workshops, a student cut some bamboo from his backyard to make bamboo pens for everyone in the class. I still use two of his bamboo pens. For larger areas, use an old no. 6 (or larger) round brush. Wash the Nib, pen or brush immediately after you finish masking.

Other Materials

For sketching, keep a soft-lead pencil, such as no. 2 and B series. I also have at least three small white dishes for mixing pure colors, packing tape for taping down the watercolor paper, one or two brush washers (containers of water), a roll of paper towels, one or two fabric towels for cleaning, one or two waste containers and a hair dryer. Also keep a roll of masking tape to lift the masking fluid, or Miskit, after your painting is dry. Cut the tape into 1" to 2" (3 cm to 5 cm) long pieces, then press it onto the Miskit. Pull up the tape to remove the Misket.

My Painting Table

Formally speaking, my painting table is not a table. I put a 3' x 4' (91cm x 122cm) smooth three-ply wooden board on a small, movable bookshelf to make my table. The advantages of having such a table are that it is handy to move it around and the bookshelf can hold painting materials.

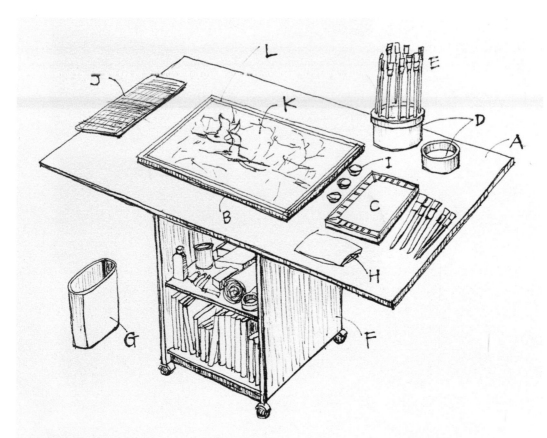

My Painting Table and Materials Layout
A. Plywood boards 3' x 4' (91cm x 122cm)
B. Smaller plywood boards 16" x 23" (41cm x 58cm)
C. Palette
D. Brush washers (containers of water)
E. Brushes
F. Bookshelf
G. Waste container
H. Paper towels
I. Small dishes
J. Fabric towel
K. Watercolor paper with its edges taped on the board
L. The taped edge

HUMMINGBIRDS AND ORCHID FLOWERS
14" x 21" (36cm x 53cm)
Watercolor on Arches 140-lb. (300gsm)
cold-press watercolor paper
Color pouring and blending

4 PAINTING BIRDS

With an overview of theories and techniques on both my Chinese paintings and water-colors, you'll be able to start painting birds, flowers and landscapes by following the painting steps in the demonstrations. In the Chinese painting demonstrations, I will show you how to paint in detail style, spontaneous style and half-detail, half-spontaneous style. In the watercolor demonstrations, I will show you my color-pouring-and-blending techniques.

ANATOMY OF BIRDS

A bird's skeleton dictates its shape. Studying the skeleton, therefore, can help you to capture the right proportions. However, I do not think it is necessary to remember all the terminology; rather, relate the skeleton to human beings. For instance, the wings correspond to human arms and hands, and the legs and feet to human legs and feet.

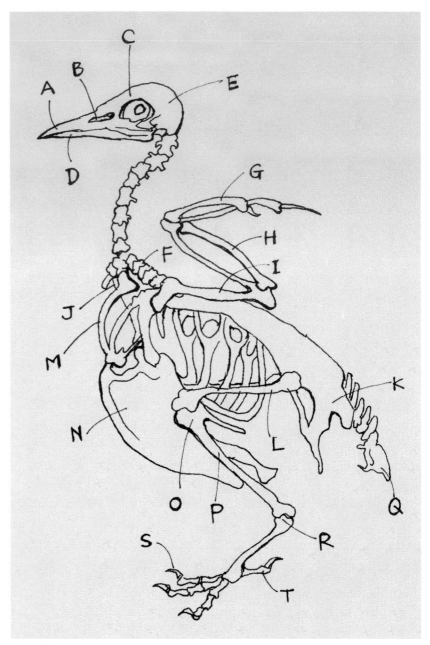

Bird Skeleton

This is a typical flying bird skeleton. Having a huge keel is an obvious feature of a flying bird. The keel is the projection from the breastbone that anchors the wing muscles. Along with the backbone, it forms the egg-shaped body. In comparison, the human chest bone is flat and proportionally smaller.

A. Upper jawbone
B. Nostril
C. Eye socket
D. Lower jawbone
E. Skull
F. Backbone
G. Metacarpus
H. Ulna
I. Humerus
J. Coracoid bone

K. Hip girdle
L. Thighbone
M. Wishbone
N. Keel
O. Knee joint
P. Lower leg bone
Q. Bony stump
R. Ankle
S. Claw
T. Hind toe

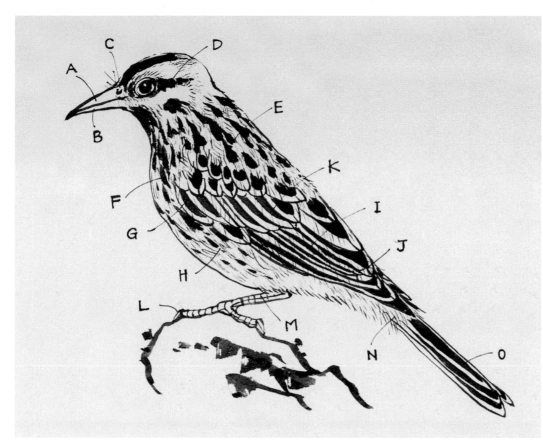

Profile of a Typical Bird

This is a sparrow in profile. Its features relate to its bones.

A. Upper jawbone
B. Lower jawbone
C. Nostril
D. Ear (hidden beneath feathers)
E. Nape
F. Breast
G. Alula
H. Flank
I. Secondary flight feathers
J. Primary flight feathers
K. Wing coverts
L. Toe
M. Tarsus
N. Tail coverts
O. Tail

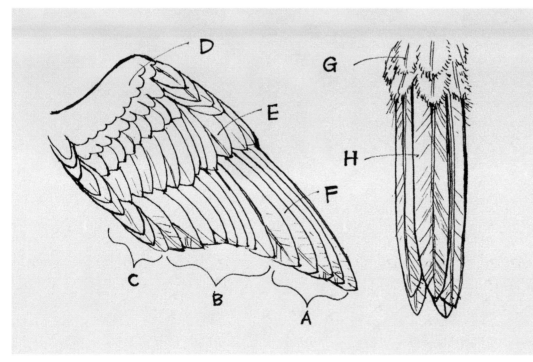

Feathers

Many birds' feathers are in arrangement similar to that shown in this sketch. Interestingly, flying birds do not have true tails. Instead, their tail feathers are attached to a bony stump.

A. and F. Primary flight feathers
B. Secondary flight feathers
C. Tertiary flight feathers
D. Lesser coverts
E. Main coverts
G. Tail coverts
H. Tail feathers

FEATURES OF BIRDS

To adapt to different environments, birds have evolved a variety of features. Following are the characteristics and features of six different groups of birds I often paint.

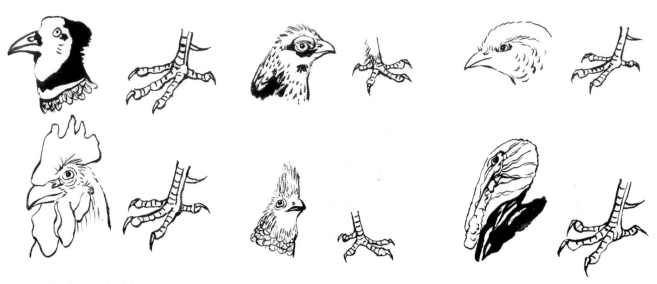

Upland Ground Birds

Chickens, turkey, pheasant, quail and peacocks are upland ground birds. These birds are good at walking but weak at flying. Therefore, they have stronger legs and smaller wings compared to many other birds. Their beaks are short and their claws are sharp. Most male birds have colorful feathers. In the top row, you see a pheasant, bobwhite and grouse. In the bottom row are a rooster, scale quail and turkey.

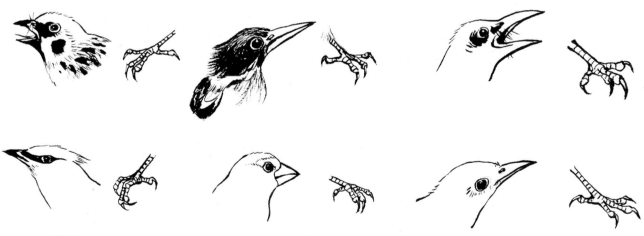

Songbirds

Many songbirds are smaller than other kinds of birds. Among them are hummingbirds, sparrows, longspurs, finches, waxwings, blue jays, kingfishers and cardinals. Compared to other kinds of birds, songbirds have strong wings and are very active. Most of them have small beaks, legs and claws. In the top row, you see a sparrow, kingfisher and crow. In the bottom are a blue jay, grosbeak and waxwing.

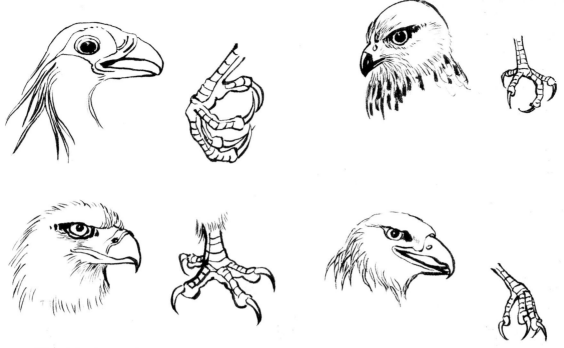

Hawklike Birds

Hawks, eagles and vultures are in the group of hawklike birds. They are built for hunting. Therefore, they are large in size, and have big wings, sharply hooked bills, strong legs and sharp claws. In the top row, you see a vulture and marsh hawk. In the bottom are a bald eagle and golden eagle.

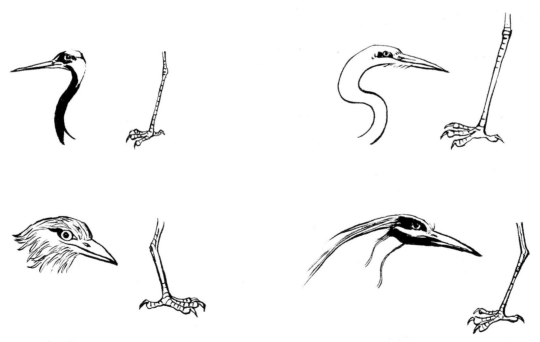

Long-Legged Birds

Long-legged birds are waterbirds with long legs adapted for wading. These birds also have long beaks and long necks. However, their tails are short. Interestingly, even though they live in water environments, they do not swim. In the top row, you see a red crown crane and white egret. In the bottom are two different kinds of herons.

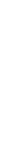

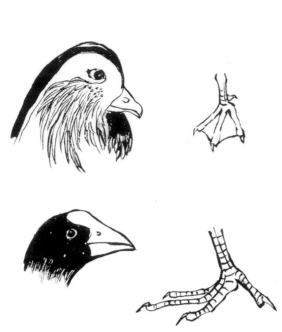

Ducklike Birds

Ducks, geese, swans and pelicans are ducklike birds. They have flat beaks, boat-shaped bodies and webbed toes (or scaly flanges). Their legs are located farther back than are other birds to enhance their swimming ability. In the top row, you see a wood duck and pelican. In the bottom are a coot and duck.

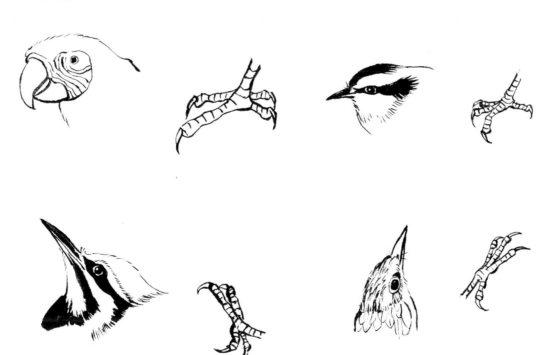

Tree-Climbing Birds

Among the tree-climbing birds are woodpeckers, nuthatches and parrots. Many of them have the distinguishing feature of standing on branches of trees with two toes in front and the other two toward the back. Their beaks are strong and sharp for cracking nuts and wood. In the top row, you see a parrot and nuthatch. In the bottom are a woodpecker and creeper.

A SIMPLE WAY TO SKETCH BIRDS

To sketch birds, relate them to geometric shapes. Interestingly, birds hatch from eggs and their bodies resemble eggs. Their tails are either a square or a fan shape and their beaks are triangular. Despite their movements and positions, their egg-shaped bodies change little. Start by drawing their bodies. Once you have established their bodies, you can easily add their heads, beaks, wings and tails.

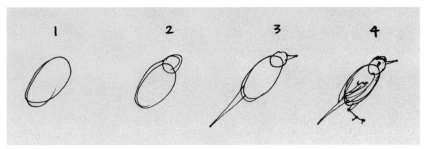

Four Simple Steps for Sketching a Bird
First, draw an egg as a bird's body. Second, add another small egg to the big egg to represent the bird's head. Third, add a narrow triangle as a tail on the one end of the big egg, and draw a smaller triangle on the smaller egg as the beak. Fourth, add eyes, wings and legs.

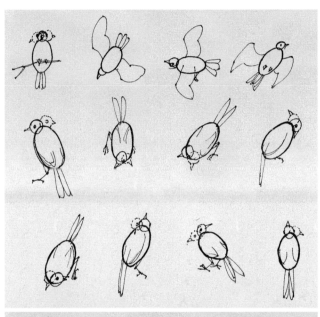

Sketch Birds in a Variety of Positions and Movements
Birds' heads, necks, wings, tails and legs are the most flexible parts. In contrast, their bodies are stable. Therefore, you should always sketch their bodies first, then move on to the other parts.

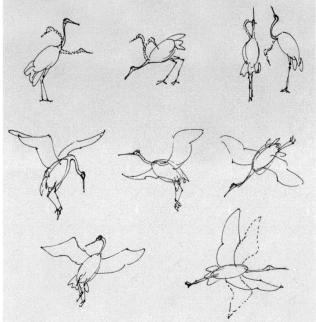

Various Positions and Movements of Cranes
The crane is one of my favorite birds. To capture its proportions, start by drawing its body.

PAINTING PHEASANTS IN DETAIL STYLE

This demonstration is a full exploration of traditional detail-style painting. Its composition is an S shape. The top of the tree leaves lie at the beginning of the S; the body of the front pheasant and the large rock are at the center part of the S; the water and the rocks at the bottom left locate the other end of the S. This S-shape composition enhances the motion of the water in contrast to the stillness of the pheasants.

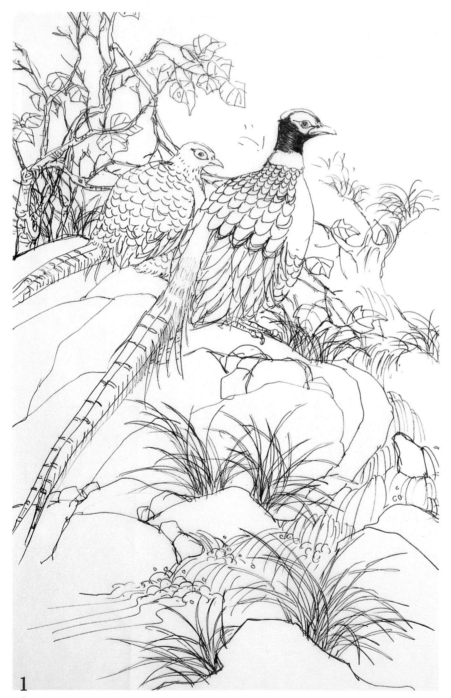

1 SKETCH WITH PENCIL AND INK PEN

On a 16" x 27" (41cm x 69cm) piece of tracing paper, sketch the images with a pencil. Next, lay a piece of mature Shuan paper on top. Trace the image with an ink pen. Add more details to the objects. Then tape the ink drawing onto the foamcore board.

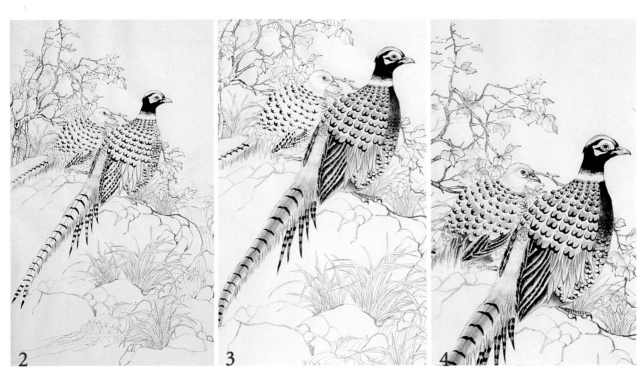

2 Paint first outline

Use an extra-small brush and intense ink to outline the male pheasant's beak, eye, coverts and back feathers. Outline the rest of the bird with light ink. Outline the female pheasant in the same way. Next, outline the weeds on the bottom near the center of the painting with light ink, then the two groups of weeds directly above. Use a small brush to outline the rocks. Next, use the same brush to paint the tree trunk and branches with the side brush method. Use the extra-small brush to outline the tree leaves. Finally, outline the water and the weeds behind the rocks and the tree.

3 Tone the male bird with ink

Paint the male bird's beak, head and eye first, then its body. Use a small brush to apply the ink, then immediately use a medium brush to blend it with water. Leave white for each flight and tail feather and for the toes and claws. After the first layer of ink is dry, tone the bird one more time in the same way.

4 Tone the female bird and the tree and weeds

Tone the female bird a couple of times as you did the male bird. Then use a small brush to tone the tree trunk and branches, leaving white on the center area of the trunk and upper parts of the branches. Next, use a small brush to apply medium ink on the center vein and the beginning part of each leaf. Immediately blend the ink into the outside edges with water. Paint two to three leaves at a time. Tone the weeds behind with an extra-small brush. Apply darker ink on the bottom part of the leaves, then blend the ink to their tips. For the overlapping areas, tone the back leaves darker.

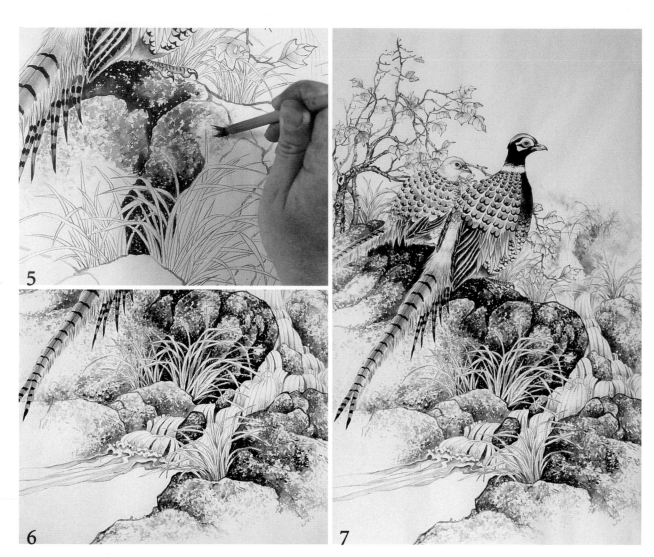

5 PAINT THE TEXTURE OF THE ROCKS

Make a medium brush into a split tip. (To make your brush multi-tipped, press a wet brush on a paper towel to absorb the water. When most of the water is gone, the brush tip will split into multitips.) With a small amount of ink, paint the rocks using the side-brush method. Apply light ink first, then medium, then intense ink last. Do not paint the weeds and the water.

6 TONE WEEDS AND WATER WITH INK

Tone the weeds as described in steps three and four. Use a small brush to apply medium ink at the bottom of each water wave. Immediately use another brush to get a small amount of water to blend the ink into middle part. Leave white on the top portion.

7 TONE THE DISTANT OBJECTS

Use a medium brush to tone the rocks and water in the background with light ink. While the ink is damp, use an extra-small brush to paint the weeds. Each brushstroke depicts one leaf. Now the painting is ready for coloring.

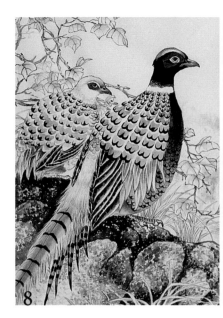 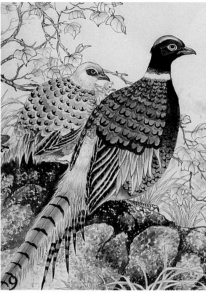 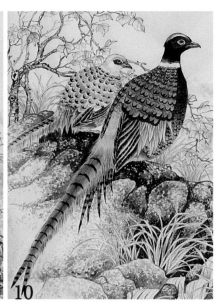

8 COLOR THE BIRDS

Use a small brush to apply intense Cinnabar around the eyes. Apply yellow on the beaks. While they are wet, apply Burnt Sienna on the tips and bottom portions of the jawbones. Paint the top of the male's head with Burnt Sienna. On the left side of the neck above the white ring, apply Phthalocyanine Blue and blend it to the Rouge at right. Next, use a medium brush to apply Rouge on the right side of the neck and the chest. Immediately, apply yellow on the abdomen and blend it into the Rouge.

9 CONTINUE COLORING THE BIRDS

Use a medium brush to paint yellow on the male bird's head and lesser coverts. Use a small brush to paint intense Cinnabar on its main coverts. Paint light yellow on the female bird's head, neck and body.

10 CONTINUE COLORING THE BIRDS

Use a medium brush to paint the tail covert feathers on the male bird with blue. Next, apply Burnt Sienna on the flight feathers for both birds. Also, paint their large tail feathers with yellow and Burnt Sienna. Define the tail feathers' fringes with light Cinnabar.

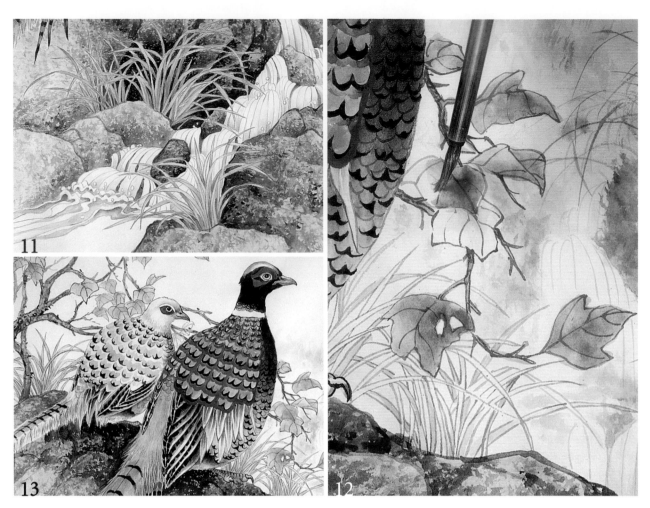

11 COLOR THE ROCKS AND WEEDS

Use a large brush to paint the rocks with light blue. Next, use a small brush to apply green on the bottom portion of each leaf. While the color is wet, use another small brush to apply Vermilion from its tip to the green. Finally, blend the two colors with a small moist brush.

12 COLOR THE TREE LEAVES, BRANCHES AND TRUNKS

Paint the leaves one by one using small brushes. Apply Cinnabar on the tip and center area of a leaf. Immediately apply green on the area near the stem and drag the green into the Cinnabar. Finally, blend the colors with water. To paint the trunk and branches, use a medium brush to mix light Indigo and Rouge into light blue-purple. Then apply it on the branches and trunks.

13 APPLY A SECOND LAYER OF COLORS ON THE MALE BIRD

In order to build up stronger saturation on the male's feathers, you need to apply a second layer of colors. Use the same brushes, colors and techniques as with the first layer of coloring to paint the feathers again.

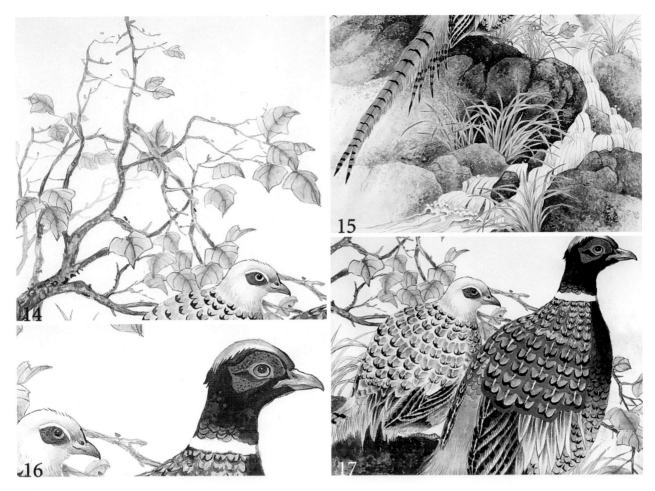

14 APPLY A SECOND LAYER OF COLOR TO THE TREE LEAVES

Use a small brush to apply Cinnabar on a leaf. While the color is wet, use a small moist brush to blend it to the edges of the leaf. Paint the leaves one by one.

15 APPLY A SECOND LAYER OF COLOR ON THE WEEDS AND MULTIPLE COLORS ON THE ROCKS

Use the same brushes and colors as described in step eleven to apply a second layer of color on the weeds. Then use an extra-small brush to paint the tip of each leaf with light Rouge. Next, use a large brush to paint the rocks with light blue. When the color is dry, apply the blue again. Finally, apply a thin layer of Rouge.

16 ADD DETAILS TO THE BIRD'S HEAD AND NECK

Use a small brush and intense Rouge to paint some dots around the eyes. Use an extra-small brush to paint light yellow on the eyeball. Then use the same brush to apply Burnt Sienna to the upper portion of the eyeball while the yellow is wet. At the left side of neck above the white ring of the male bird, apply intense blue.

17 ADD DETAILS TO THE FEATHERS

Use a small brush to paint the center part of each covert with dark brown mixed from intense ink and Burnt Sienna. When the color is dry, use a small brush to paint an intense white stroke on the center of each of the feathers. Then use an extra-small brush to paint small diagonal, intense ink strokes on each primary flight feather.

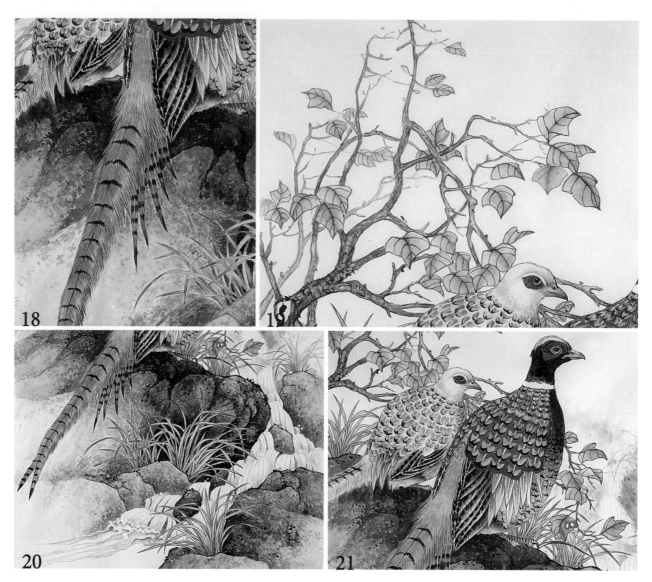

18 ADD DETAILS TO THE TAILS

Use an extra-small brush to call out the small tail covert feathers with
white. On the large tail feathers, paint small strokes on the bottom of
each black stripe with intense white. Also, add tiny strokes on the
edges of the large tail feathers with intense Cinnabar.

19 PAINT THE SECOND OUTLINE ON THE TREE

Use extra-small brushes to outline the trunk and branches with ink
that is darker than the first outlines. Mix ink and Rouge to outline the
leaves. Try to match the first outline strokes.

20 PAINT THE SECOND OUTLINE ON THE ROCKS AND WEEDS

Use a medium brush to outline the rocks with ink that is darker than
the previous outlines. Add some intense ink dots randomly on the
rocks, a technique known as *calling out the moss*. Mix Rouge and ink
to outline the upper part of the weeds. Mix ink and Indigo to outline
their lower portions.

21 PAINT THE SECOND OUTLINE ON THE BIRDS

Use an extra-small brush to outline the beaks, heads, necks, feet,
claws and feathers with intense ink. Outline the body of the male bird
with Rouge and ink. Outline the body of the female bird with Burnt
Sienna and light ink.

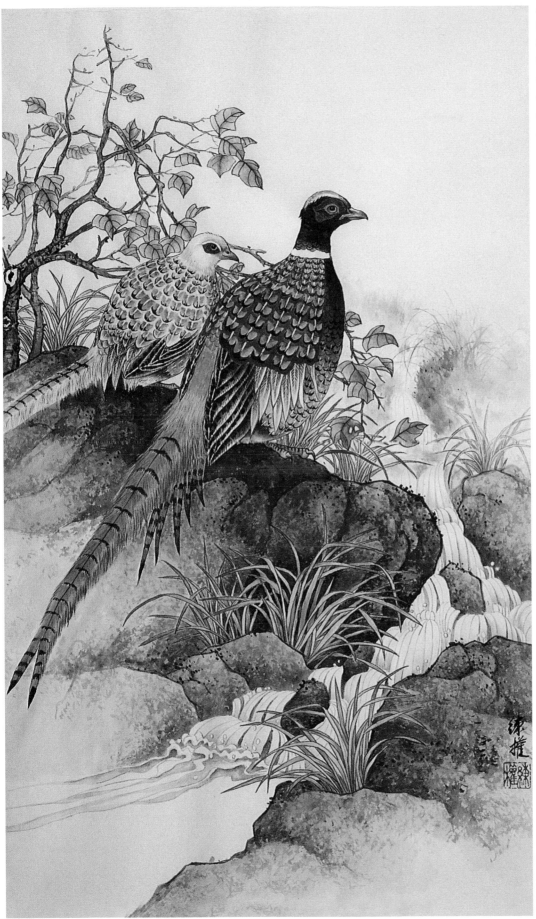

Sign your name to the lower right corner and stamp your chop below it. Because your signature and chop are not needed for balance in this composition, hide them in the rocks.

PHEASANTS
16" x 27"
(41cm x 69cm)
Chinese ink and colors on mature Shuan paper
Detail style

PAINTING AN EGRET IN HALF-DETAIL, HALF-SPONTANEOUS STYLE

This painting has a triangular composition. The wing on the left, the top portion of the bamboo post and the lotus leaves behind form the tip of the triangular shape. The net, the lotus leaf, the signature and the chop on the lower right form the right side of the triangular shape. Likewise, the net and lotus leaves on the left form the left side.

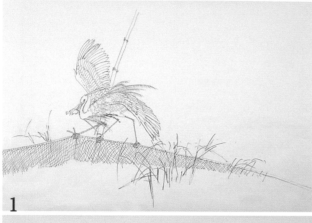

1 SKETCH ON TRACING PAPER

Place a 17" x 24" (43cm x 61cm) piece of tracing paper on foamcore board and tape down its corners. Sketch the images with pens.

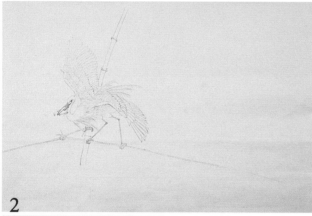

2 PAINT FIRST OUTLINE

Lay a 17" x 24" (43cm x 61cm) piece of mature Shuan paper on top of the sketch and tape its corners onto the board. Use an extra-small brush to paint the outlines of the bird first, then move to the net ropes and finally to the bamboo post. Paint the beak and eye of the egret with intense ink and the rest with light ink.

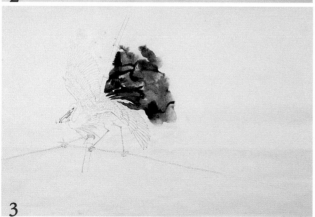

3 PAINT THE BACKGROUND AT RIGHT

Use a large brush to wet the background at right without wetting the bird. Immediately, apply intense ink next to the bird with a medium brush. In addition, apply medium Rouge and Phthalocyanine Blue onto the ink with another large brush. Let the colors blend into each other.

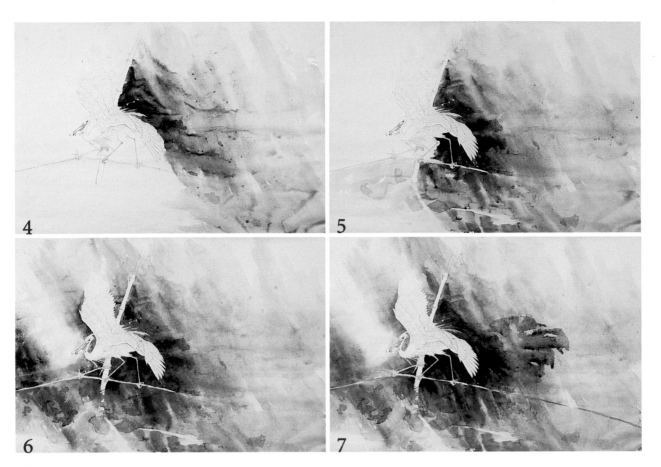

4 CONTINUE TO PAINT THE BACKGROUND AT RIGHT

Use a small brush to guide the colors for defining the edge of the wing and bamboo. Wet the background at far right. Then use a large brush to apply yellow and Cinnabar to the center and upper portions. Next, apply Phthalocyanine Blue to the lower part to create the water effect. Use a large brush to blend the colors.

5 DEFINE THE SHAPE OF THE EGRET

Apply intense ink between the legs and the front wing with a medium brush. Then use a small brush to define the outlines of the feet, the body and front wing by dragging the ink toward the outlines of the bird. Use a large brush to add Rouge on the right and lower center of the background.

6 PAINT THE BACKGROUND AT LEFT AND CONTINUE TO DEFINE THE SHAPE OF THE EGRET

Wet the background at left, then apply ink and Indigo. Leave white above the bird's head. At the edge of the rear wing, drag the colors diagonally to the upper left with a large brush. The diagonal strokes will create the illusion of rain.

7 PAINT THE LOTUS LEAF NEXT TO THE FRONT WING

Fill a large brush with Rouge, then add intense ink to its tip. Hold the brush sideways and move it quickly from the center of the leaf to its edge so that you create an effect called *fly white*, the white areas on the leaf.

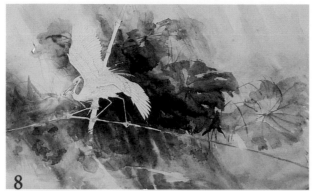

8

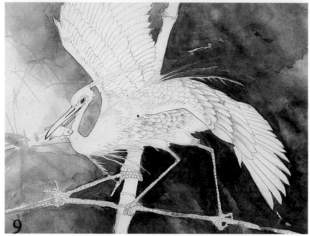

9

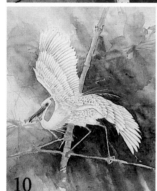

10

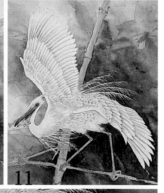

11

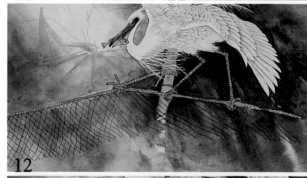

12

13

8 PAINT THE OTHER LOTUS LEAVES AND WEEDS

Use the same brush to paint the leaf above with lighter Rouge and ink. Paint the other leaves with light Rouge, yellow and a little ink. When it's raining, lotus leaves hold water in their center areas. Thus, leave the lighter background colors at their center. To finish the leaves, use a medium brush to paint the veins with medium ink and Rouge. Next, use a small brush to mix ink and Vermilion. Paint the weeds while the colors on the leaves and background are damp.

9 PAINT THE EGRET'S FEATHERS

Use a small brush to mix Burnt Sienna and light ink. Apply the colors at the beginning of each feather. Then use another small brush to blend the colors with water toward the tip. Paint the feathers one by one.

10 PAINT THE OTHER AREAS OF THE BIRD, BAMBOO POST, NET ROPES AND FISH

After you are finished painting the feathers, use a small brush to paint the beak and eye with yellow. Then apply Vermilion to the beak and around the eye. Add Rouge to the tip of the beak, then apply light blue at the tip and nostril. Next, use a small brush to paint the feet with blue and Vermilion. Use a medium brush to mix yellow, blue and Burnt Sienna to paint the bamboo post. Paint the ropes with yellow and Vermilion. Paint the fish with yellow, Vermilion and blue.

11 ADD DETAIL TO THE FEATHERS AND PAINT THE BREEDING PLUMAGE

Use an extra-small brush to paint the centerline of each feather and the breeding plumage(narrow, fringed feathers) with very intense white. Apply your brushstrokes from the bird's body outward. In addition, paint white at the tips and edges of the other feathers. Next, use an extra-small brush to mix yellow, Vermilion and white to outline and call out the texture of the feet.

12 PAINT THE NET AND APPLY SECOND OUTLINE ON THE BIRD, THE FISH AND THE ROPES

Use an extra-small brush to paint the net with intense ink. Next, paint the second outlines using intense ink on the bird's eye, beak and feet; using Burnt Sienna and ink on the neck; using Indigo and ink on the fish; and using Burnt Sienna and ink on the ropes.

13 PAINT WATER DROPS ON THE NET

Use an extra-small brush to mix Vermilion and white. Randomly apply the color to the threads of the net.

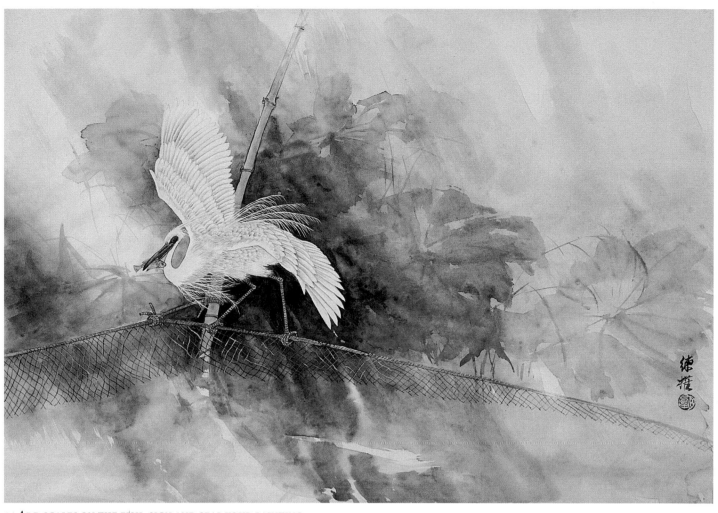

14 ADD SCALES ON THE FISH, SIGN AND SEAL YOUR PAINTING

Use an extra-small brush to mix Vermilion and white. Paint small dots on the fish as scales. Finally, sign your name and stamp your chop on the lower right corner. They will balance the bird on the left.

FISHING IN THE RAIN
17" x 24" (43cm x 61cm)
Chinese ink and colors on mature Shuan paper
Half-detail, half-spontaneous style

PAINTING PEACOCKS IN SPONTANEOUS STYLE

Most accomplished Chinese artists do not sketch their spontaneous compositions before they paint. However, you can use a charcoal stick to sketch your images on Shuan paper before you paint. Do not draw details because spontaneous-style paintings tend to lack careful organization. You may change objects' shapes and colors during the painting process according to the developing composition and your mood and style of expression.

The composition of this painting is a reverse C shape. Even though the peonies are at the front, the colorful male peacock is the focal point. In contrast to other spontaneous-style paintings in this book, this painting has more details.

1 *SKETCH ON TRACING PAPER*

Sketch the images and composition on an 18" x 27" (46cm x 69cm) piece of tracing paper with an ink pen. Keep in mind that you do not have to paint all the objects you have sketched. In fact, the flower tree behind the birds is not in my finished painting.

2 *SKETCH ON THE SHUAN PAPER*

Place a piece of double-layer Shuan paper the same size as the tracing paper on top of the sketch, then trace the images with the charcoal stick. Draw only the main outlines of the objects. When finished tracing, scrape off any excess charcoal.

3 *PAINT THE LESSER COVERTS ON THE FRONT WING OF THE MALE PEACOCK*

Use a large brush to mix yellow and Indigo, then add intense ink on its tip. Paint a few brushstrokes with the center-brush method. Next, make the brush into a split tip. Use ink to paint the split brushstrokes. Then use another large brush to mix Rouge, light ink and yellow to paint the lesser coverts at left.

4 PAINT THE MAIN COVERTS

Use a large brush to mix intense ink and a little Rouge to paint the main coverts. Then paint an intense ink stroke on the center of each lesser covert.

5 PAINT THE FLIGHT FEATHERS

Use a large brush to paint the flight feathers with Vermilion and light ink. Paint the brushstrokes from the tip of the feathers to the main coverts. Each stroke depicts one feather. When the feathers are halfway dry, use a small brush to paint a stroke at the center of each flight feather with intense ink. Also, use a medium split-tip brush to paint the texture with ink and Vermilion.

6 PAINT THE REAR WING AND THE TAIL COVERTS

Paint the rear wing in the same way as the front wing. Then use a small brush to paint the tail coverts with ink.

7 PAINT THE CIRCULAR PATTERNS OF THE TAIL

Use a medium brush to paint the center black spots with intense ink. Next, use another medium brush to mix Carmine and Rouge to paint the strokes around the black spots.

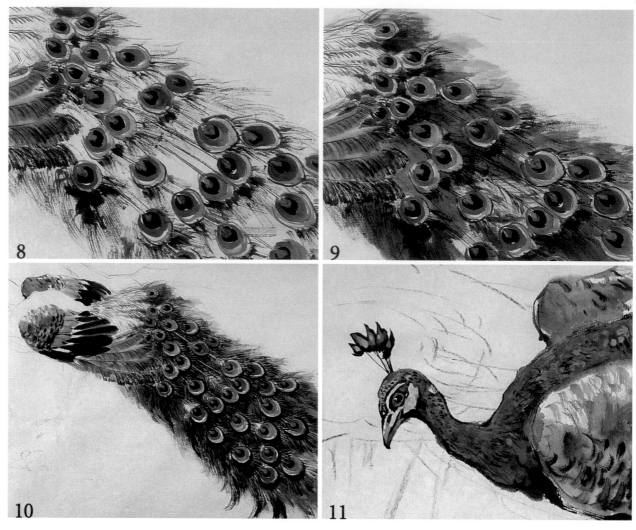

8 *Finish the circular patterns and paint the texture of the tail feathers*

Use a medium brush to paint the outlines of the circular patterns with ink. Then paint light blue inside the outlines. Next, apply intense blue at the center of the circles. Paint Vermilion and yellow on top of the dark red strokes on each pattern. Next, use a split-tip brush to paint the tail feathers with ink, moving your brush from the edges of the circular patterns outward.

9 *Color the tail feathers*

Use a big brush to mix Phthalocyanine Blue, yellow and ink to paint the tail feathers. Use lighter colors on the upper part of the tail.

10 *Add details to the tail feathers*

When the colors are halfway dry, use a small brush to paint intense ink strokes diagonally from each circular pattern outward. Also, apply white to the centers of the feathers.

11 *Paint the head, neck and back*

Use a medium brush to apply intense ink on the head, neck and back. Also outline the eye, the face and the beak. While the ink is wet, apply blue on top of the head, neck and back. Then use a small brush to paint small feathers with intense ink. Next, color the eye, face and beak with yellow. Add Cinnabar to the eye. Apply Cinnabar and ink to the beak.

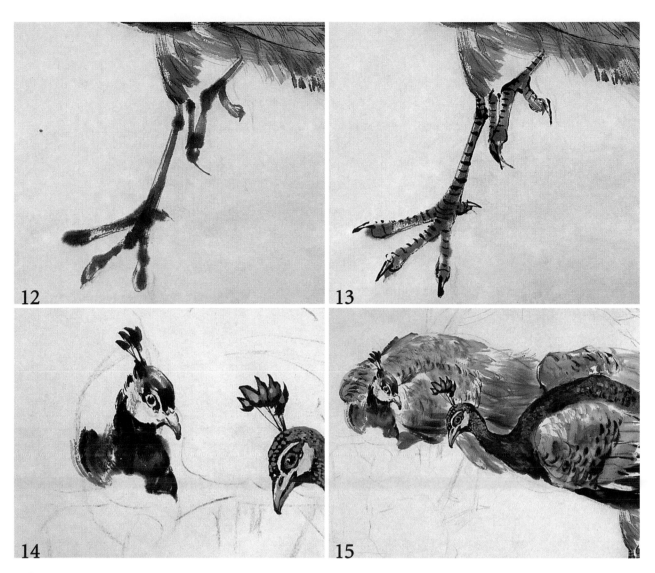

12 PAINT THE FEET
Use a medium brush to mix ink and Burnt Sienna. Hold your brush
in the center-brush position and paint several strokes for the feet.

13 PAINT THE TEXTURE OF THE FEET AND PAINT THE CLAWS
When the colors are halfway dry, use a small brush to define the tex-
ture of the feet with intense ink. Also paint the claws.

14 PAINT THE HEAD AND NECK OF THE FEMALE BIRD
Use a medium brush to outline the female bird's beak and eye with
intense ink. Then mix ink and Burnt Sienna to paint the head and neck
with center-brush strokes.

15 PAINT THE BODY OF THE BIRD
Use a large brush and light Burnt Sienna to paint the body and wings.
While the color is wet, define the feathers with medium and intense
ink. Also, mix Cinnabar and light ink to paint the main coverts.

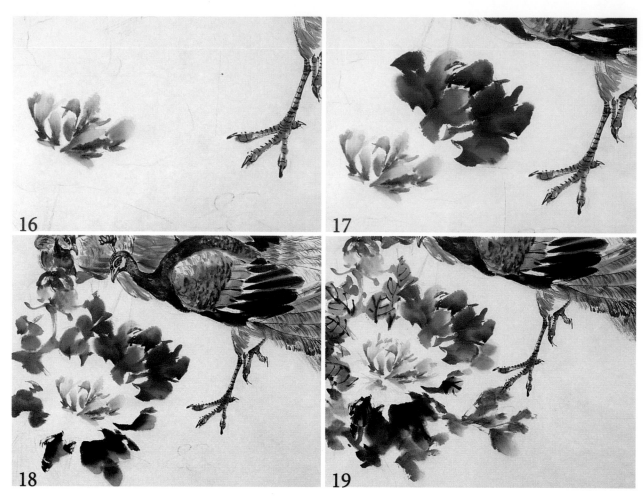

16 *Paint the pink petals of the peony*

Soak a large brush with white. Get Carmine up to its middle portion and Rouge at its tip. Use the side-brush method to paint the peony petals. Place the tip of your brush pointing toward the center of the flower. Paint one or two strokes to depict a petal.

17 *Paint the red petals*

Soak a large brush with Cinnabar, then Carmine up to its middle portion. Mix Rouge and ink with its tip. Paint the petals with the side-brush method, pointing your brush tip toward the center of the flower. Leave white on the top area of the pink petals to depict white petals.

18 *Paint the redbud and leaves*

Use a large brush to mix Vermilion and yellow. Paint three center-brush strokes at the bottom of the bud. Immediately use the large brush used for painting the red petals to paint the upper part of the bud. Next, dip a large brush in Indigo. Get intense ink on its middle and tip area to paint the leaves at the bottom of the pink-white flower. Use the same brush to mix yellow, Indigo and ink. Hold your brush using the side-brush method to paint the other leaves.

19 *Paint more leaves and redbuds*

Use the same brush and colors to paint more leaves. When they are halfway dry, paint the veins with ink. Next, use the brush used to paint red petals to paint two more redbuds behind the leaves. Use a medium brush to mix Vermilion, yellow and ink. Then paint the stem at lower left with the center-brush method.

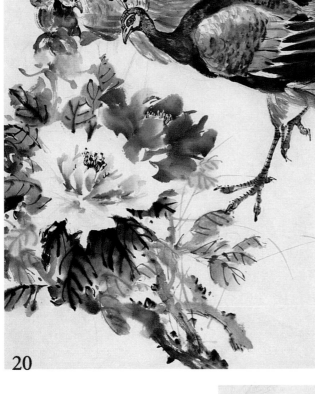

20 PAINT THE TRUNKS, STAMEN AND LONG GRASSES

Use a large brush to mix ink and a little Carmine to paint the trunks with the side-brush method. While the trunks are wet, randomly add some intense ink dots and Carmine spots on the trunks to emphasize their textures. Next, use a small brush to mix yellow and white to paint the stamen on the red flower. Mix Carmine and intense ink to paint the stamen on the pink-white flower. To paint the lone grasses, use a small brush to mix light ink and Carmine and make long strokes. Hold your brush per the center-brush method, and move it from the bottom of the grasses to their tips.

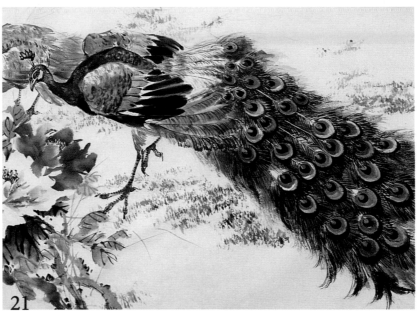

21 PAINT THE SMALL GRASSES ON THE GROUND

Use a split-tip medium brush to paint short strokes with different intensities of ink. Overlap the strokes to create the grass texture.

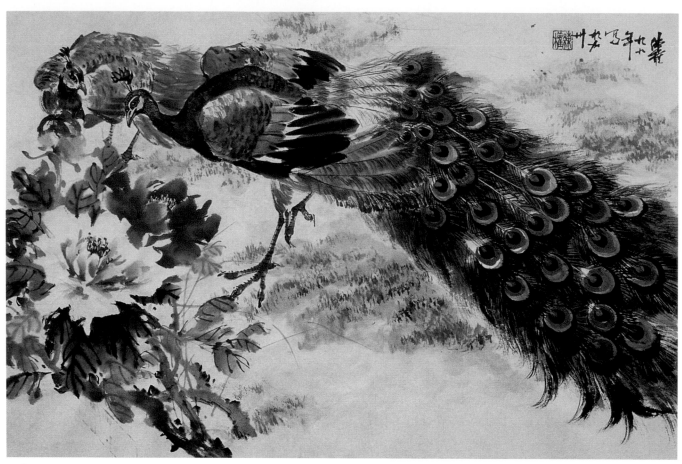

22 *APPLY COLORS ON THE GRASSES, SIGN AND*
SEAL YOUR PAINTING

Use a large brush to mix Burnt Sienna and light ink to color the grasses. Apply less-intense colors on the distant grasses. Finally, sign your name, the date and the place of the painting.

PEACOCKS AND PEONY
18" x 27" (46cm x 69cm)
Chinese ink and colors on double-layer Shuan paper
Spontaneous style

PAINTING DUCKS

I used only the three primary colors for all the watercolor demonstrations. They are Cadmium Red Deep from Winsor & Newton and Cadmium Yellow Light and Ultramarine Blue from Utrecht. I will refer to these colors as red, yellow and blue in the demonstrations. The paper is Arches 140-lb. (300gsm) cold-press watercolor paper. The masking material is Grumbacher's Miskit Liquid Watercolor Frisket.

Before painting, I used masking tape to tape about ½" (1cm) at the four edges of the paper to a three-ply plywood that was larger than the paper. The 1"- or 1 ½" (3cm or 4cm)-wide brown 3M masking tape is best because it holds the paper firmly.

As you work, feel free to change the objects and composition according to the results you get at each stage. Remember, there are no mistakes.

1 SKETCH THE DUCKS

Use a soft pencil to sketch the ducks on a 14" x 21" (36cm x 53cm) Arches 140-lb. (300gsm) cold-press watercolor paper. Do not draw details.

2 MASK THE DUCKS AND PREPARE COLORS

Apply the Miskit on the ducks. To prepare the colors, add about 1/4 cup (6ml) of clean water to each dish. Then add pigment approximately the size of the bristles of a no. 6 round brush from each tube into the separate dishes (one color per dish). (The amount of water and pigment you need depends on the size of your painting and the intensity of color you want.) Use three small brushes to stir the colors until they blend with the water, using one brush per color.

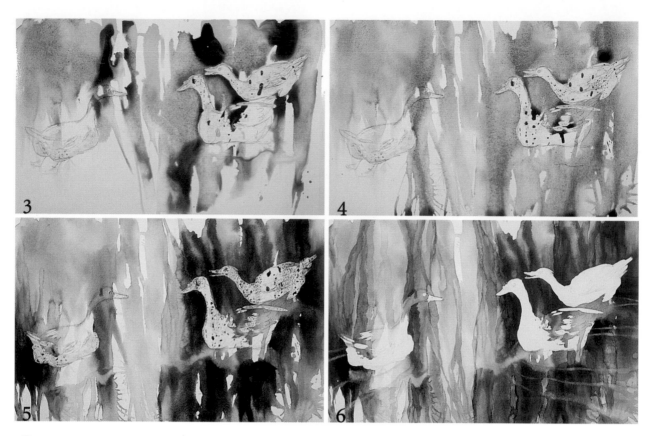

3 DRY THE MISKIT AND POUR THE COLORS

Wait for the Miskit to dry or use a hair dryer to dry it. Use a water sprayer to lightly wet the painting. Pour the yellow paint at the upper middle, where the sunlight reflects. Pour the blue paint on the right and left. Finally, pour the red paint below the yellow.

4 DIRECT THE FLOW OF THE COLORS

Tilt the upper edge of the painting up about 5" (13cm) so that the colors flow toward the bottom. Use your mouth to blow the colors at the middle bottom and right bottom to get the radiation effects.

5 PAINT THE WATER AND REFLECTIONS

While the colors are wet, use a 1-inch (25mm) flat brush to mix intense blue and a little red. Paint the water around the ducks. The intense colors will cause the ducks to appear to pop out from the paper, especially the white duck at the upper right. Next, use a moist no. 8 round brush to lift colors to create the reflections of the two ducks at front.

6 CREATE MOVEMENT OF WATER AND REFLECTIONS OF TREES, AND LIFT THE MISKIT

When the colors are almost dry, use a ³⁄₄-inch (19mm) flat brush to mix yellow and blue into green to paint the reflections of trees. Next, use a no. 10 round brush to paint vertical strokes with blue. This will further emphasize the water. Before the colors dry, use a moist no. 6 round brush to lift colors off the water for waves. When the painting is totally dry (I use a hair dryer to dry it), use masking tape to remove the Miskit.

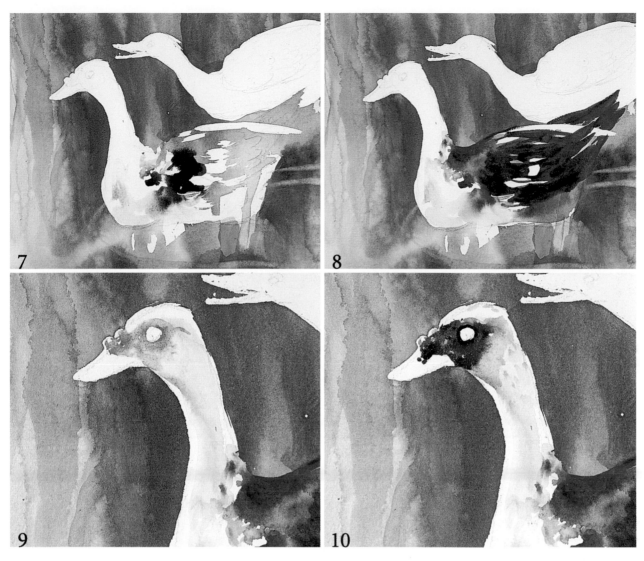

7 PAINT THE DUCK AT FRONT RIGHT

Use a ¾-inch (19mm) round brush to wet the duck's body with water. Mix very intense blue and red into black to paint the front wing. Let the color blend into the water to create soft feather effects. Paint the chest with light purple mixed from light blue and light red.

8 CONTINUE PAINTING THE DUCK

Use the ¾-inch (19mm) flat brush to paint the back, wings and tail with dark blue, mixing from intense red and blue. Leave white for the white feathers. While the colors are wet, use a no. 10 round brush to apply yellow on the back to create the green feathers.

9 PAINT THE HEAD AND NECK

The duck's neck and head are mainly white. Use a no. 10 round brush to wet them with water. Mix light red and blue to paint the neck. Mix yellow and red, making orange, to paint the face and nostril, leaving a white circle for its eye.

10 APPLY MORE COLORS ON THE HEAD AND FACE

While the orange is wet, use a no. 10 round brush to get intense red and paint on top of it. Immediately use the same brush to get intense blue on its tip to paint the dots on the red area. Also, outline the eye circle again.

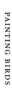

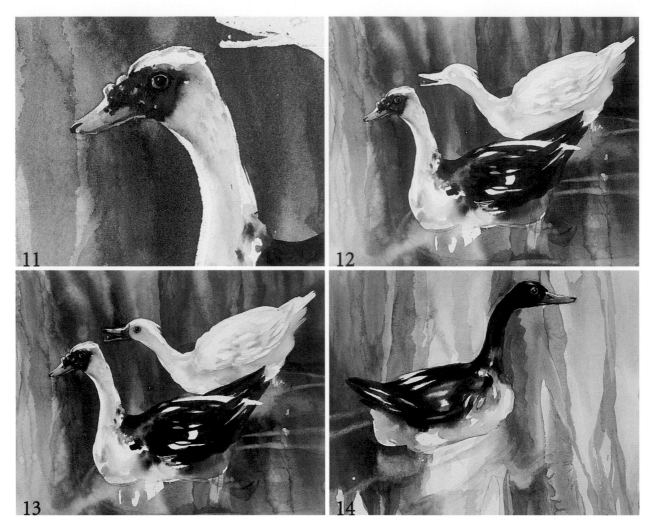

11 Paint the beak and eye

Use a no. 6 round brush to apply yellow to the eyeball and beak. Drag the colors from the nostril area to the upper jawbone. Paint the edges of the jawbones with red. Next, mix the red and blue into black to paint the pupil, leaving a white spot as the highlight.

12 Paint the body and wings of the second duck

Use a ¾-inch (19mm) flat brush to apply light yellow on its neck and back. Paint light purple on its body and wings. Leave a lot of white. In the area between its front wing and body, paint more intense purple.

13 Paint beak and eye

Use a no. 6 round brush to mix yellow and red into orange. Paint the jawbones and eyeball. Leave white on top of the upper jawbone and at the upper pupil. While the colors are wet, use the same brush to mix a little blue and red to define the jawbones and outline the eye. Finally, get very intense blue and a little red to paint the pupil.

14 Paint the duck at left

Use a no. 10 round brush to lightly wet the head, neck and body. Leave the white feathers untouched. Paint the middle and bottom part of the neck with red. Mix intense red and blue to paint the other part of the neck and the head. Next, use a ¾-inch (19mm) flat brush to mix intense blue and red to paint the feathers on the back and wings. Use another wet ¾-inch (19mm) flat brush to drag the colors into the lower part of the body with water. Paint its eye and beak as in step thirteen.

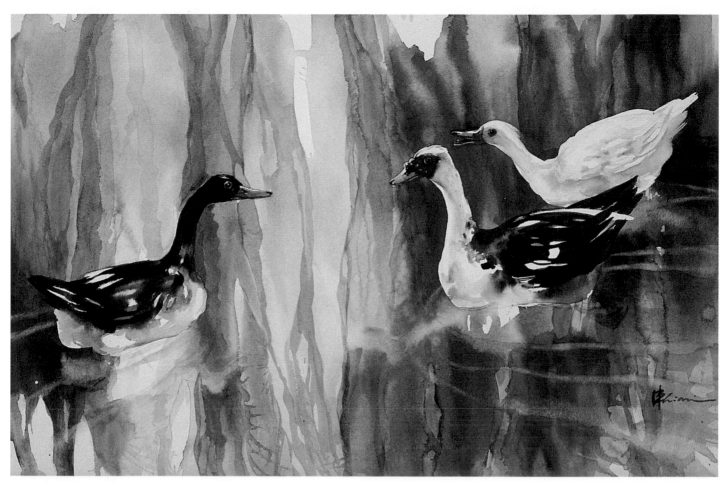

15 SIGN YOUR PAINTING

Sign your name on the bottom right of your painting. Your painting will be different from mine even though we used the same colors and techniques. This is because the colors blend differently after you pour them on your painting. I have never been able to paint two paintings the same or even very similar. Actually, when I paint using the color-pouring-and-blending method, I do not know what exact result I will have before I finish.

SUNSET AT SWAMP
14" x 21" (36cm x 53cm)
Three primary colors on Arches 140-lb.
(300gsm) cold-press watercolor paper
Color pouring and blending

PAINTING CRANES

This painting will use a lot of Miskit for preserving the sky, cranes and snow. If you stretch your paper before you paint, you can use masking tape instead of the Miskit to block out the snow area at the bottom of the painting. However, do not use the masking tape if you do not prestretch the watercolor paper. Here is the reason: The upper portion of the paper will be very wet and will contract strongly when it is dry, while the lower portion of the paper will not contract since it is taped with masking tape. Therefore, the finished painting will warp too much.

1 SKETCH THE IMAGES AND APPLY MISKIT

Use a pencil to sketch the images on your 21" x 29" (53cm x 74cm) Arches 140-lb. (300gsm) cold-press watercolor paper. Apply Miskit to the sky at top, to the birds and grasses at middle and to the snow at bottom. Splatter Miskit on the tree area diagonally from upper left to lower right for snowflakes.

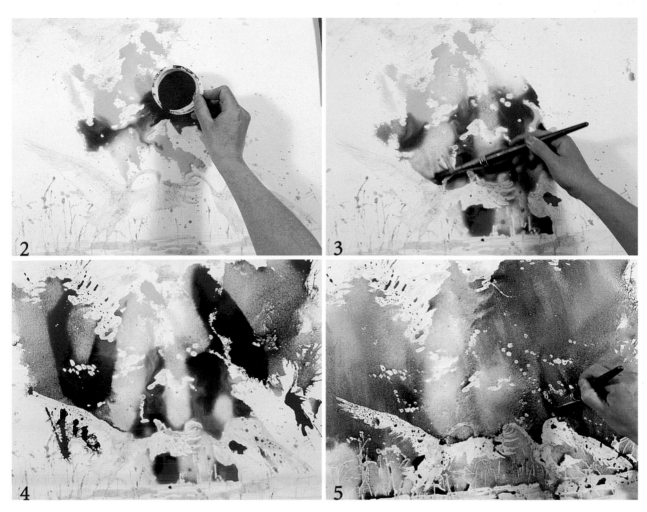

2 WET THE PAINTING AND POUR THE COLORS

Use a hair dryer to dry the Miskit. Prepare the colors as described in step two of the duck demonstration (page 87), preparing about twice as much color as previously used. Wet the painting with a water sprayer. Next, pour the yellow and red on the upper center area where sunlight is shining through the trees.

3 DIRECT THE COLORS

Pour the blue on the lower part of the yellow and red. Use a 1½-inch (38mm) flat brush to direct the colors toward the birds. Also, guide the colors to touch each other so they can blend gracefully.

4 POUR MORE COLORS

On the upper left of your painting, pour some blue. On the upper right corner, pour blue and red. Blow the colors at right toward the right edge of your painting to create abstract trees. Spray more water on the middle right and middle left to guide the colors down.

5 DIRECT THE FLOW OF THE COLOR, PAINT THE TREES AND GRASSES

Tilt your painting board toward you with the upper left corner highest. The colors will flow diagonally from the upper left toward lower right. This creates diagonal patterns on the trees, the illusion of wind movement and falling snowflakes. Next, put a 3" to 4" (8cm to 10cm) high object under the top left corner of your board to keep the colors flowing in the same direction. While the colors are wet, use a 1½-inch (38mm) flat brush to add intense blue and red on the trees.

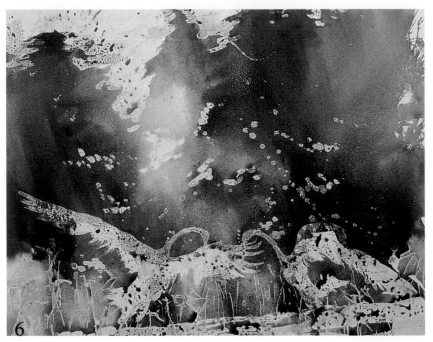

6 ***DEFINE THE TREES AND GRASSES AND APPLY SALT***

Continue to use the 1½-inch (38mm) brush to define the shapes of trees with intense blue and red. (Note: *Intense* color refers to adding a little water to the pigment, whereas *very intense* refers to a pigment without water. *Light* color means to use more water to dilute the color.) Paint the area against the upper portions of the wings darker to pop the white feathers of the cranes. Pour more yellow on the grass area in the middle of the painting. Apply about forty to fifty pieces of cooking salt on the trees. Put more of them in the center area, around the head of the bird at left.

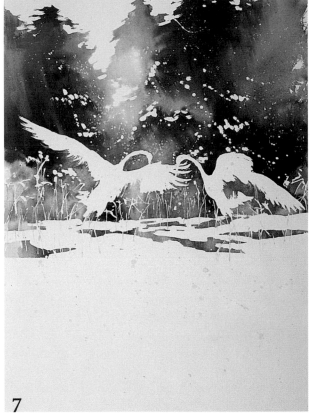

7 ***LIFT THE MISKIT AND SPLATTER SMALL MISKIT SPOTS A SECOND TIME***

Dry the painting with a hair dryer. Lift the Miskit using masking tape. Next, use an old round brush to randomly splatter the Miskit on the snow and the birds. Use the Incredible Nib to apply the Miskit on the lower portions of the grasses. Dry the Miskit with a hair dryer.

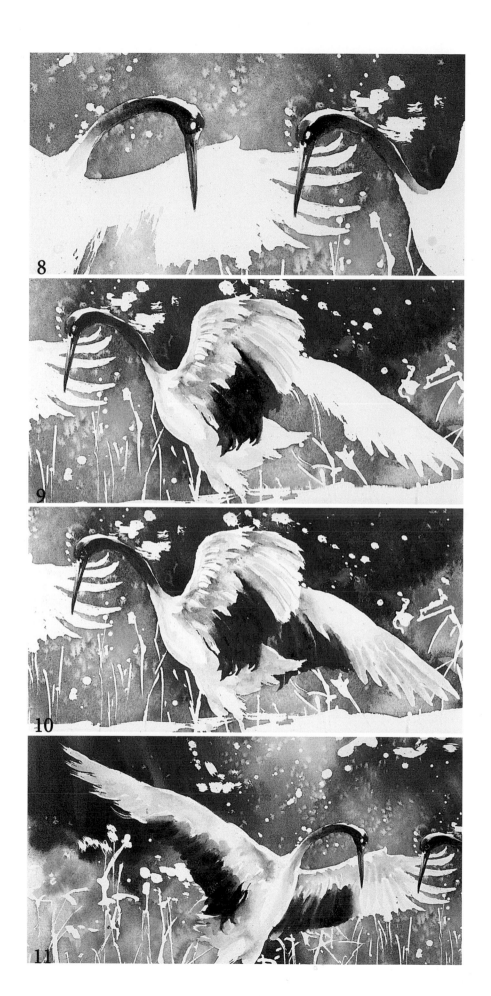

8 PAINT THE HEADS, BEAKS AND NECKS OF THE BIRDS

Use a no. 6 round brush to apply yellow on the beaks, then apply red on the middles and tips of the beaks. Wet the tops of the heads with water. Paint the combs with very intense red. Next, use a no. 10 round brush to wet the necks without touching the upper edges. Mix intense red and blue to paint the wet area. Use the no. 6 round brush to mix intense red, yellow and a little blue into dark brown to define the beak.

9 PAINT THE FRONT WING OF THE CRANE AT RIGHT

Use a no. 6 round brush to wet the small coverts. Apply light blue and light red on them to define the feathers. Paint light yellow on the primary flight feathers. Next, wet the black feather area with a no. 10 round brush. Use a no. 8 round brush to mix very intense blue and red (do not mix them completely). Paint the black feathers in a few strokes.

10 PAINT THE REAR WING, THE TAIL AND THE BODY

Paint the right crane's rear wing in the same way as the front wing. Leave more whites. Wet the chest and abdomen with a no.10 round brush. Apply light purple to define the chest, the thighs and the tail. Drag the colors from the black feathers into the tail feathers.

11 PAINT THE WINGS AND BODY OF THE CRANE AT LEFT

Paint the wings and body in the same way as done for the bird at right (see steps 9 and 10). When painting the flight feathers of the rear wing, leave white between the feathers.

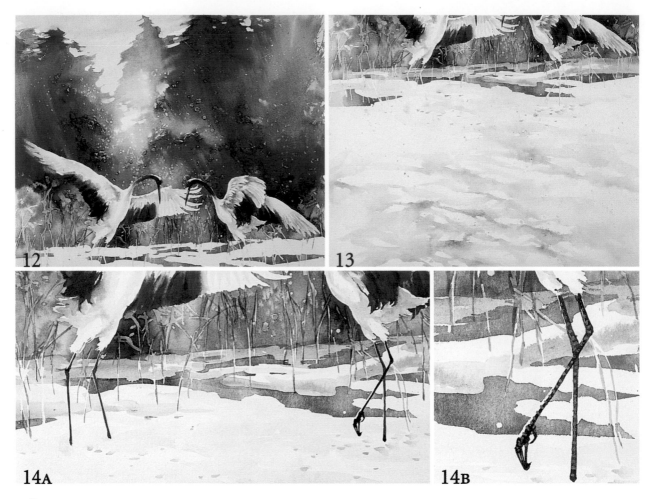

12 *FILL IN COLORS FOR THE WHITE SPOTS, PAINT*
THE GRASSES AND THE SKY

Use a no. 6 round brush to apply red and yellow to the white spots
near the sunlight and to those on the grass area. Apply blue to the
white spots on the trees. Mix intense red and yellow to paint the grass-
es. Use a 1-inch (25mm) flat brush to wet the upper area of the sky.
Apply light yellow in the center area. Also, paint light red and blue on
it. Use a 1½-inch (38mm) flat brush to drag the colors from the tree-
tops into the sky using water.

13 *PAINT THE SNOW*

Lightly spray water on the snow area. Use a 1-inch (25mm) flat brush
to paint the snow with different intensities of blue. In the center area
below the cranes, apply light yellow and red on top of the blue while
the blue is wet. Then use a ¾-inch (19mm) flat brush to blend the col-
ors with water. This will create sunlight reflections on the snow.

14 A & B *LIFT THE MISKIT, PAINT THE GRASSES AND THE FEET*

Lift the Miskit. Use a no. 6 round brush to mix red, yellow and a little
blue into brown. Paint the lower portions of the grasses. Leave white
to depict the snow on the stems. Next, use the same brush to paint
the feet with very intense blue and red. While the colors are wet, paint
intense yellow strokes to define the texture.

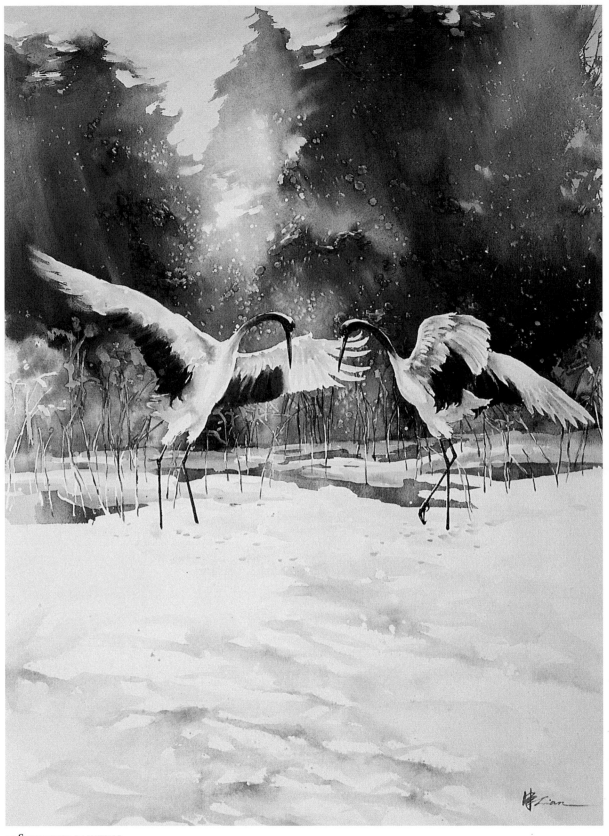

15 Sign your painting

Sign your name at bottom right to balance the composition.

HARMONY
21" x 29" (53cm x 74cm)
Watercolor on Arches 140-lb. (300gsm) cold-press watercolor paper
Color pouring and blending

TWO CICHLIDS
16" x 20" (41cm x 51cm)
Chinese ink and colors on mature Shuan paper
Detail style

PAINTING
FIG FISH

It is important to capture the essences of fish when you paint them. Their creative shapes, magnificent colors, and graceful movements are wonderful features to depict. When I am painting fish, I focus on the integration between fish and water. Fish and water are inseparable naturally and spiritually. Therefore, fish is water and water is fish.

ANATOMY OF FISH

The fish I usually paint are teleosts, or bony fish. Among them are goldfish, angelfish, koi, butterfly fish and coral fish. Even though they live in different environments, they have similar skeletons that have two major functions: first, to form supporting frameworks for the internal organs and tissues, and second, to provide a series of flexible joints and attachment points for muscles to enable the fish to move. From the artist's viewpoint, it is not important to paint a fish exactly like a particular species, such as the ones I have mentioned. Keep in mind that you are painting, not illustrating. Do not let the fish control you. Feel free to rearrange and change fish colors and shapes to suit your creativity. When I paint goldfish, for example, I often choose the most beautiful features from all kinds of goldfish. As a result, I create my own goldfish.

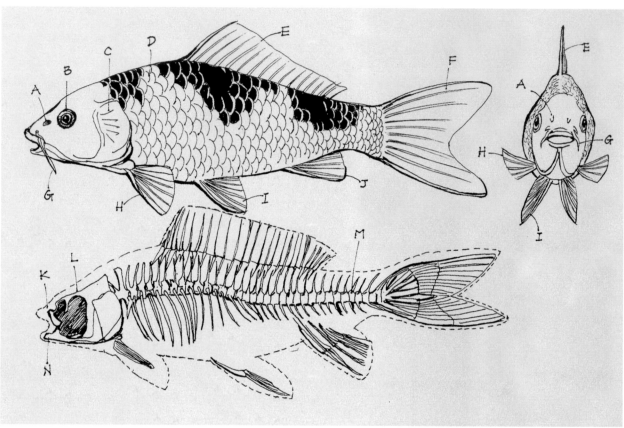

Fish Skeleton
This is a koi skeleton, along with side and front views of a live koi. They clearly show how the skeleton forms the fish's framework, which supports and articulates its body.
A. Nostril
B. Eye
C. Gill
D. Scale
E. Dorsal fin
F. Tail
G. Barbels
H. Pectoral fin
I. Ventral fin
J. Anal fin
K. Upper jaw
L. Skull
M. Spine
N. Lower jaw

FEATURES OF FISH

Koi

Despite the beautiful color patterns, koi are still carp from an anatomical viewpoint. Their cylindrical bodies are broader at the front and narrower at the rear. This shape minimizes turbulence as the fish moves through the water. The widest point of a koi is between the pectoral fins and the beginning of the dorsal fin. A koi may grow up to 30" (76cm) long and weigh about 22 pounds (10kg).

A koi's pectoral and ventral fins are in pairs. Its dorsal and anal fins are single fins. The dorsal fin works the same as the keel of a ship to keep the fish upright. When a koi swims fast, its dorsal fin is low and the other fins are close to its body to create a more streamlined effect. When its pectoral and ventral fins counteract the gills' action (which tends to create forward movement), the fish is motionless.

The face of the koi extends to the tip of its head. As a result, it has an inferior mouth. There are paired barbels on its upper lip. These are sense organs that help the fish locate food. Like many fish, a koi does not have eyelids. There are two nostrils in front of its eyes. These sense hormones released by other organisms and fish.

The koi's scales are transparent, overlap one another and become larger as the fish gets older. Scales do not provide color for a koi. Instead, the amount of reflective tissue in the skin beneath the scales determines the various colors. The less reflective the scales, the more intense a koi's color will be. The pigments found in the tissues are red, orange, yellow, brown and black.

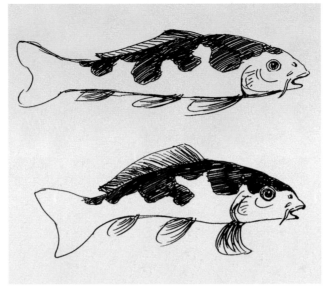

Koi
At top left is a speeding koi. Notice how the dorsal fin is lower and the other fins are narrower. The other koi is stationary, with its pectoral fins moving forward.

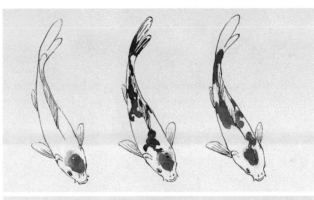
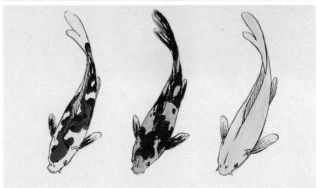

Koi Coloring
Here are some of the common colors and patterns on koi.

Goldfish

Goldfish also belong to the carp family. One major difference between goldfish and koi is that goldfish do not have barbels. In addition, goldfish are much smaller than koi. Most of them have deep, ball-shaped bodies. They can reach 8" to 10" (20cm to 25cm) long in about six years.

Similar to koi, goldfish have scales that are transparent. Pigment cells underneath the skin provide coloration for the fish. Some of my favorite goldfish are the ryukin, the oranda, the shubunkin, the lionhead, the telescope eye, the bubble eye and the veiltail.

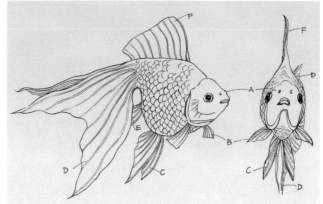

A Typical Goldfish
A. Nostril
B. Pectoral fin
C. Ventral fin
D. Tail
E. Anal fin
F. Dorsal fin

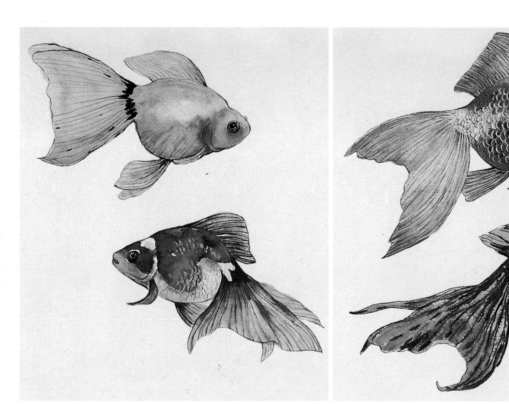

Ryukin and Veiltail Goldfish

A typical ryukin has a short, deep ball-like body and a hump in the shoulder area. Its tail is long and forked. Its fins are also lengthy. The fins and tail are magnificent when the fish is moving. I often choose ryukins as focal points in my goldfish paintings.

The bottom right-hand fish is a veiltail goldfish. It was bred in the United States during the early 1920s. Its special characteristics are the unusually long fins and tail that gracefully display when the fish is moving in water, as if it were a bride dancing in her wedding gown.

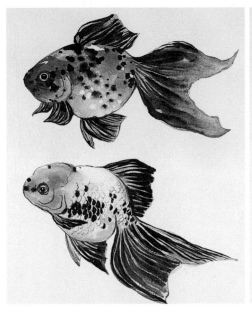
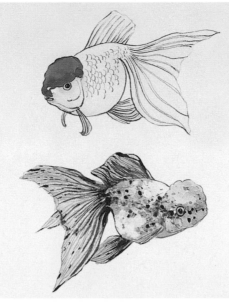

Oranda Goldfish
A very special feature of this fish is its hood, or the outgrowth of skin on its head, which encases the whole head except its eyes and mouth. There are various colors of hoods. I like to place a hood as a focal point in my painting compositions.

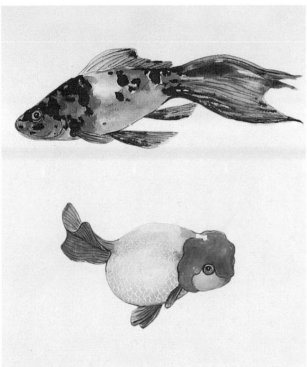

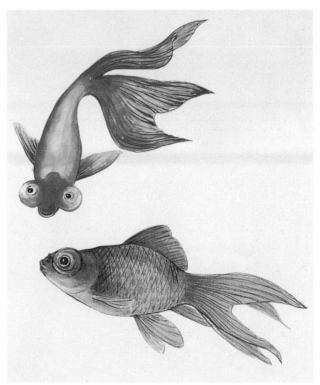

Shubunkin and Lionhead Goldfish

At the top is a shubunkin goldfish, also called a calico goldfish. Unlike other goldfish, it has a slim body that can grow to about 6" (15cm) long. Shubunkins' bodies have patches of red, yellow and black, along with dark inklike speckles on their bright blue or purple flanks.

At the bottom is a lionhead goldfish. Similar to the oranda, it is also hooded. It looks shorter than other goldfish because its fins and tail are very short. It does not have a dorsal fin.

Bubble-Eye and Telescope-Eye Goldfish

At the top is a bubble-eye goldfish. From its name, you can tell the feature of the fish: two big bubble eyes. Some eyes are even bigger than the fish's body. Bubble-eye goldfish have slim bodies, similar to the shubunkin. The majority of them are red.

At the bottom is a telescope-eye goldfish. Obviously, the goldfish has telescope-like popping eyes. Many of them are brown-black.

Angelfish

Unlike koi and goldfish, angelfish have thin bodies. They look like diamond shapes in head-on views and profiles. Angelfish can grow to 6" (15cm) in length and 10" (25cm) in height. They have huge dorsal and anal fins. Their magnificent long, narrow ventral fins curve into beautiful sweeping arcs when they are in motion.

Typical characteristics are the four vertical black stripes on the flanks of many angelfish. The first stripe runs through the eyes. The second goes from the beginning of the dorsal fin to the vent. The third is the longest, traveling from the end of the dorsal fin through the body and down to the end of the anal fin. Finally, the fourth stripe lies at the beginning of the tail.

Among the angelfish, my favorites are the veiltail, black lace-veil, marbled veiltail, ghost, yellow-black and gold crown.

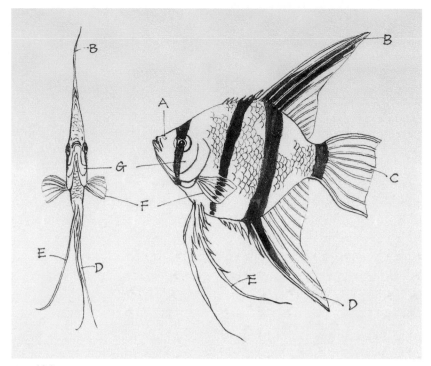

Angelfish

A. Nostril
B. Dorsal fin
C. Tail
D. Anal fin
E. Ventral fin
F. Pectoral fin
G. Gill

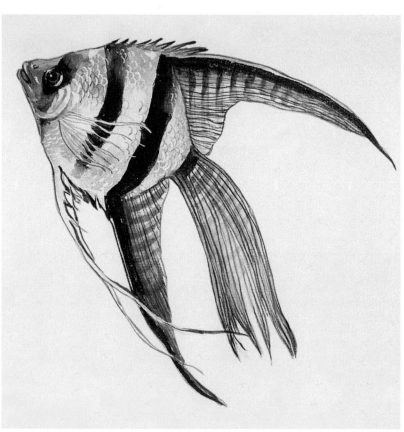

Veiltail Angelfish

This is a common angelfish. The most striking features are its lengthy fins and tail, along with four black stripes on its body. Its head, shoulder and dorsal fin are yellow-orange.

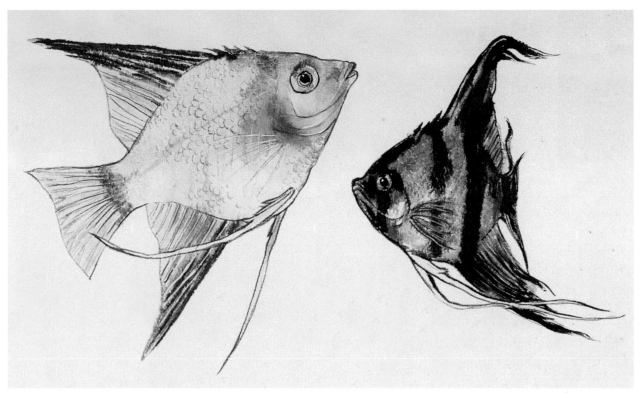

Ghost and Black Lace-Veil Angelfish

Ghost angelfish, like the left fish above, have semitransparent bodies. You can even see the bones and stomach through its muscles. The most distinguishing characteristic is a red area on and around its gill.

Besides having the four black stripes, black-lace angelfish, like the right fish above, range from light silver-gray to black. I often put a dark-colored black lace-veil behind a light-colored angelfish to get strong contrasting effects.

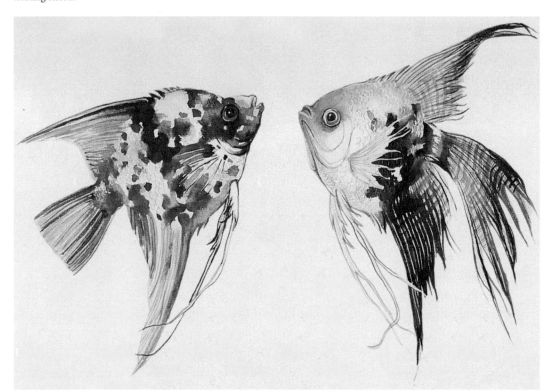

Marbled Veiltail and Yellow-Black Angelfish

The left fish is a marbled veiltail angelfish. Instead of having uniform stripes, it has random black patterns on its flanks, as if the four black stripes were deformed. In addition, it has unusual horizontal bars on its tail.

At right is the yellow-black angelfish. It is a handsome fish, featuring yellow-gold on its upper body, along with silver-white on the lower body. Black patterns are gracefully distributed on its fins, flanks and tail. In addition, it has a magnificent long tail.

Butterfly Fish

Butterfly fish are tropical fish with beautiful coloration. Their body shapes resemble those of angelfish: slim and flat. Some butterfly fish have dorsal and anal fins that blend into their bodies and extend to their tails. An adult fish is about 6" to 8" (15cm to 20cm) in length. Their colorful, flat bodies are like butterflies. Some of my favorites are the long-nosed, threadfin, three-banded, black-back, pennant and Philippine pennant.

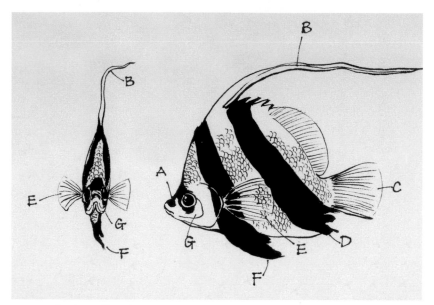

Front and Side Profiles of a Butterfly Fish
A. Nostril
B. Dorsal fin
C. Tail
D. Anal fin
E. Pectoral fin
F. Ventral fin
G. Gill

Long-Nosed Butterfly Fish
This is also called a copper-banded butterfly fish. Both names describe the two major features of this fish. In addition, the fish has a black spot on its dorsal fin, similar to the black spots on a butterfly.

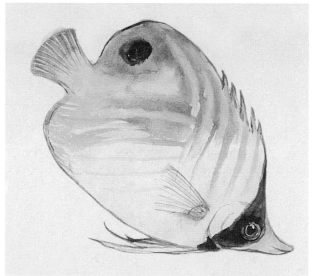

Threadfin Butterfly Fish
Its mouth is shorter than that of the long-nosed. A black band comes down from its head, crosses the eyes and ends at the bottom of its gill. About sixteen brown pinstripes lie gorgeously on its body.

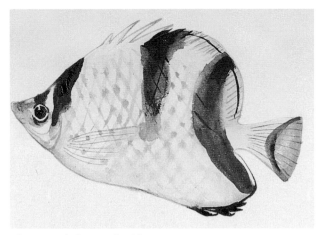

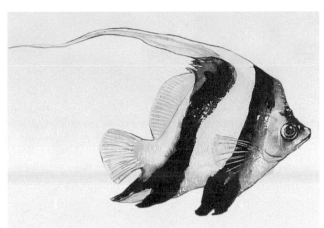

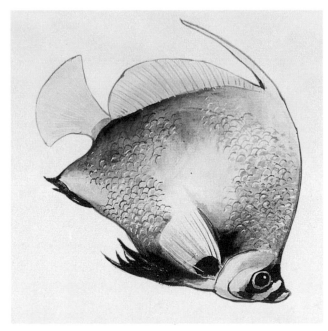

Three-Banded Butterfly Fish

It has three small, threadlike black bands. The first one is on its dorsal fin. The second one is on the anal fin, and the third one is on the tail. This butterfly fish has a silver-white body.

Black-Back Butterfly Fish

It has a medium-length mouth and four black bands running vertically along its body, along with some thin black stripes. This fish has beautiful coloration of yellow, orange and light silver-blue.

Pennant Butterfly Fish

I like to paint this fish a lot because it has a magnificent long dorsal fin and pretty black bands on its body. In addition, the fish has simple and strong contrasting colors: yellow, black and white.

Philippine Pennant Butterfly Fish

Its dorsal fin is shorter than the pennant. It does not have the large black bands; instead, it has two smaller black bands on its head and mouth.

HOW TO SKETCH FISH

The techniques for sketching fish are similar to those for sketching birds. In the beginning, you should relate the fish to geometric shapes instead of focusing on details. It is not easy to get the appropriate proportions and perspectives of the fish, especially when sketching moving fish. You can use a fish model made of metal, plastic or ceramic to help you. I have fish tanks at home, so I can watch the fish a lot. Following are some simple processes for sketching fish.

Sketching Koi

The koi's body relates to a cylinder shape with arcs at both ends. Therefore, start by drawing a cylinder shape. Next, draw a line from one end of the cylinder to the other to indicate the centerline of the fish. The line defines the top of the fish's head, dorsal fin and tail. Once you have established the centerline, sketch the head on one end of the cylinder and the tail on the other. Finally, draw the fins.

What part and how much of the koi you can see are determined by the viewing angles between you and the fish. Pay attention to the angles in order to get proper perspectives.

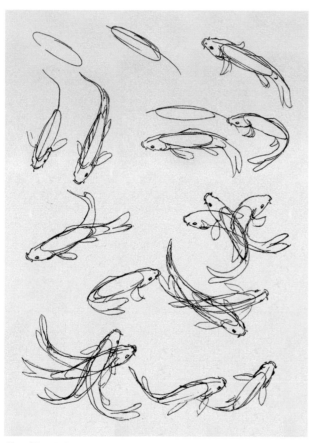

Sketching Koi
These koi sketches show aerial views. The koi displays its color, shape and movement very well from such angles.

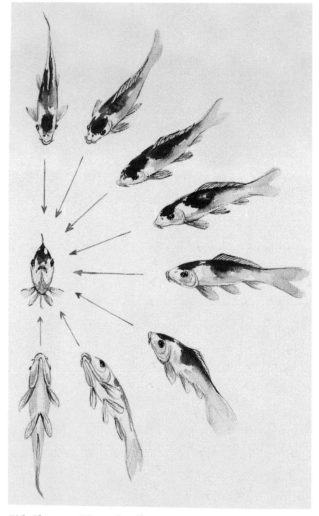

Fish Change as Viewpoint Changes
In this illustration, the arrows indicate viewing angles. The fish at the beginning of each arrow corresponds to the angle.

Sketching Goldfish

First sketch an egg as the body. Next add smaller eggs at one end to establish the gill and head. Place a little circle on one egg as an eye, then sketch the fins and tail. Once you get the overall shape and perspective of the fish, add details.

Sketching Angelfish

Start with a diamond shape to indicate the body and head. Add two triangular shapes on the top and bottom of the diamond as dorsal and anal fins. Next, place another triangle between the fins, representing its tail. Draw a circle on its head as the eye and define the gill. At this point, you have established the basic form of the fish and you can add more details. When sketching a fish swimming toward you, start with a narrower diamond shape. Accordingly, the triangular shapes are also narrower. If the fish is tilted at an angle, the geometric shapes should be tilted, too.

Sketching Butterfly Fish

Sketching a butterfly fish is very similar to sketching an angelfish except it requires an egg shape rather than a diamond shape for the body.

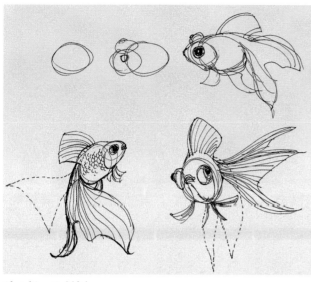

Sketching Goldfish
Here are some simple ways to sketch goldfish.

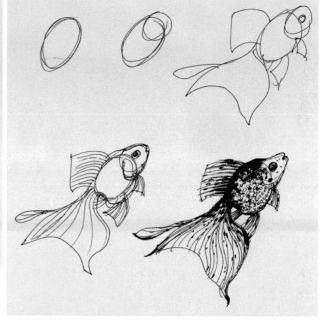

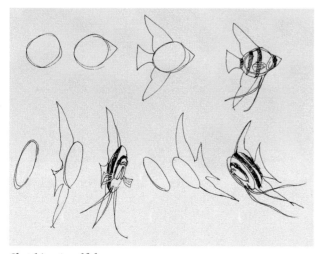

Sketching Angelfish
This shows some simple ways to sketch angelfish.

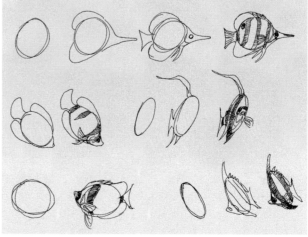

Sketching Butterfly Fish
Here are sketches of butterfly fish at different angles.

PAINTING GOLDFISH IN DETAIL STYLE

This painting has an arc-shape composition. Three fish, the major objects, form an upward curving arc. This helps to emphasize the activity of the fish. The plants in the background form minor vertical forces that break the arc, further enhancing the movement of the fish and water.

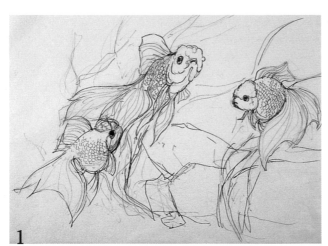

1 SKETCH THE IMAGES

Get a 15" x 19" (38cm x 48cm) piece of tracing paper or sketch paper. Roughly sketch the fish and plants with a pencil. Next, use an ink pen to draw the objects again with more details.

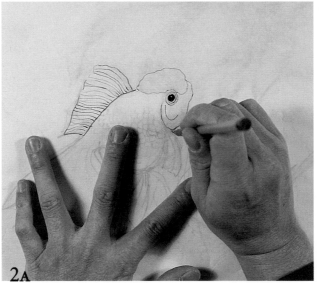

2 A & B OUTLINE THE FISH WITH INK

Place a 15" x 19" (38cm x 48cm) piece of mature Shuan paper on top of your sketch and tape its corners down with drafting tape. Use an extra-small brush to outline the fish with ink. Hold the brush according to the center-brush method. Apply intense ink on the eyes and light ink on the other parts. Paint the fish at bottom left first.

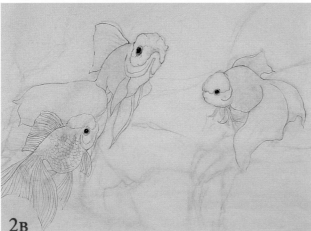

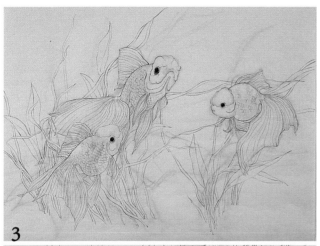

3 OUTLINE THE PLANTS

Use the same brush as in step two to outline the plants with light ink. Feel free to change the shapes of the plants. Paint the front leaves first. You do not have to paint continuous long strokes, but keep your brushstrokes smooth.

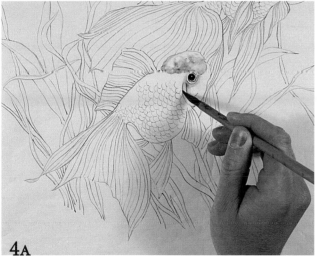

4 A & B TONE THE BOTTOM LEFT FISH WITH INK

Use two medium brushes for toning. One is for inking and the other is for blending. Use the blending brush to lightly wet the fish. Next, use the inking brush to apply medium ink on the crown and around the eye. Leave some white on the crown. While the ink is wet, use the blending brush to blend it. Next, tone the other parts of the fish in the same way.

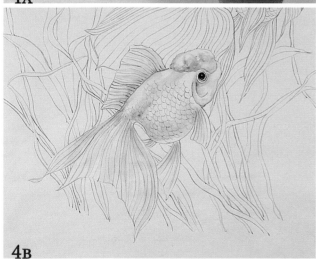

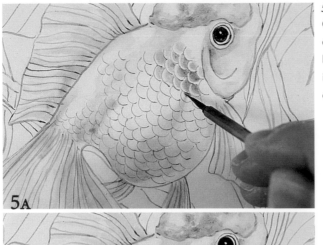

5A

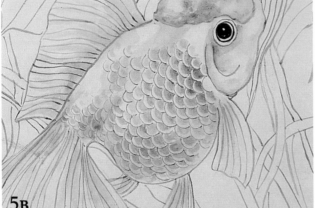

5B

5 A & B Tone the scales

Once the ink is dry, use two small brushes to tone the scales one by one. For each scale, use the inking brush to apply medium ink at the base. Immediately use the blending brush to blend and drag the ink into the edges and tip. Use lighter ink for the scales on the upper part of the body where it catches the light.

6 Tone the other two fish

Even though these two fish are different from the one you just painted, use the same technique to tone them. For the circular scales on the upper left fish, leave white at the center of each scale rather than at the edges.

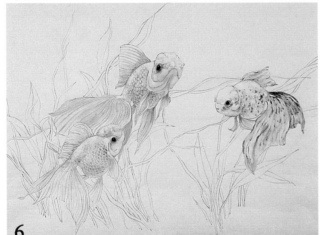

6

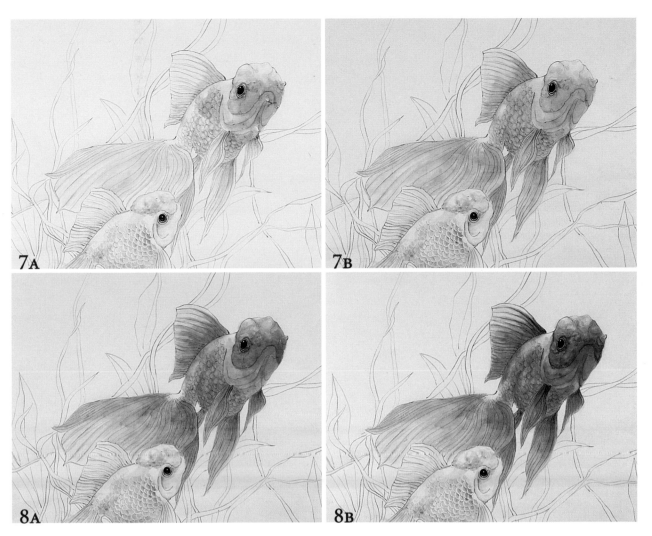

7 A & B APPLY COLOR ON THE FISH AT UPPER LEFT

After the ink is dry, use a large brush to lightly wet the head and body. Use a medium brush to apply light yellow on the crown and medium yellow on the gill and back. Immediately use another medium brush to apply Carmine on the bottom parts of the crown, mouth and body. Smoothly blend the colors. Paint the other parts of the fish in the same way.

8 A & B ADD MULTIPLE LAYERS OF COLOR TO THE FISH

Wait for the colors to dry. Use the same brushes and colors to paint the fish a second time. Dry the colors and paint a third time. With each layer, apply more intense colors than used for the previous layer.

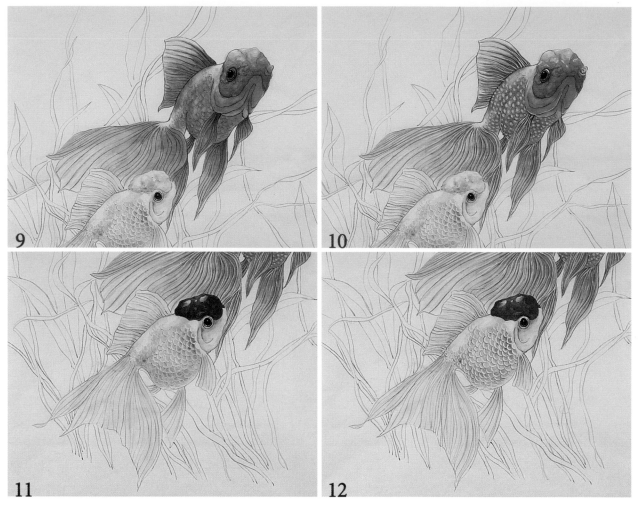

9 PAINT SECOND OUTLINE ON THE FISH

Use an extra-small brush to mix intense Carmine and ink. Hold your brush straight to paint the second outlines over the first outlines.

10 ADD DETAILS

Use an extra-small brush to paint long strokes on the tail and fins with intense white and yellow. Use a medium brush to paint the spots on the scales with intense yellow. Highlight the crown and upper area of the eye with white.

11 COLOR THE FISH AT BOTTOM LEFT

Use a large brush to lightly wet the fish. Apply light yellow. Next, apply very light Carmine at the bottom of the body. Use a medium brush to paint the crown with intense Carmine. Immediately add Rouge to the lower portion. While the colors are wet, use another medium brush to blend the colors into the eye area. Add yellow around the eye and gill.

12 ADD DETAILS

Use an extra-small brush to mix Carmine and yellow to paint the long strokes on the tail and fins. In addition, outline the scales. Next, use a small brush to highlight the scales with very intense white. Finally, paint the eyeball with Carmine, yellow and ink.

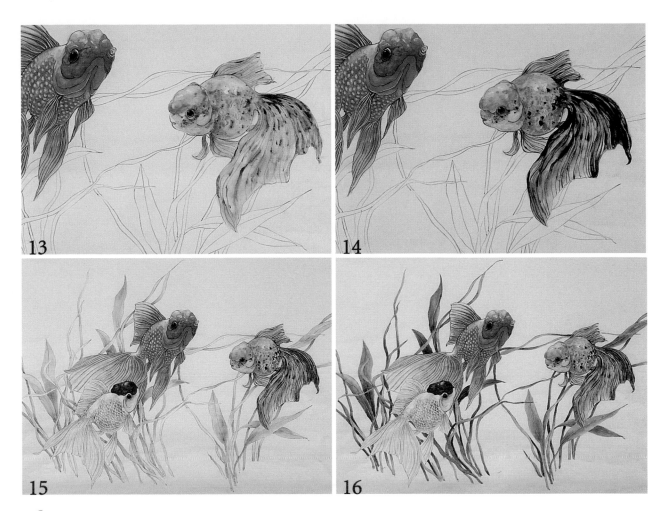

13 Color the fish at right

Lightly wet the fish. Use a medium brush to mix yellow and Vermilion. Paint the crown, gill, mouth and lower portion of the body. Next, apply Phthalocyanine Blue on the upper portion of the body, the fins and the tail. Finally, apply yellow and Vermilion to the top of the dorsal fin, the beginning of the pectoral fin and the upper part of the tail.

14 Add intense ink to the tail and fins

When the colors are halfway dry, use a medium brush to add intense ink on the tail and fins. In addition, paint some intense ink spots on the body and gill.

15 Paint the details of the fish and tone the plants with ink

Use an extra-small brush to mix very intense white and a little light Carmine. Paint the tiny and long strokes of the fins and tail. Also, use a small brush to highlight the scales with the same colors. Next, use two medium brushes to tone the leaves of the plants with ink one by one. Wet a leaf with one brush, then use the other brush to apply medium ink on the lower part. Immediately blend the ink with the wetting brush.

16 Color the plants

Wait for the ink to dry. Use a medium brush to mix yellow and Indigo to paint the leaves. After the colors dry, paint them again with the same brush and colors. Leave a centerline on each large leaf.

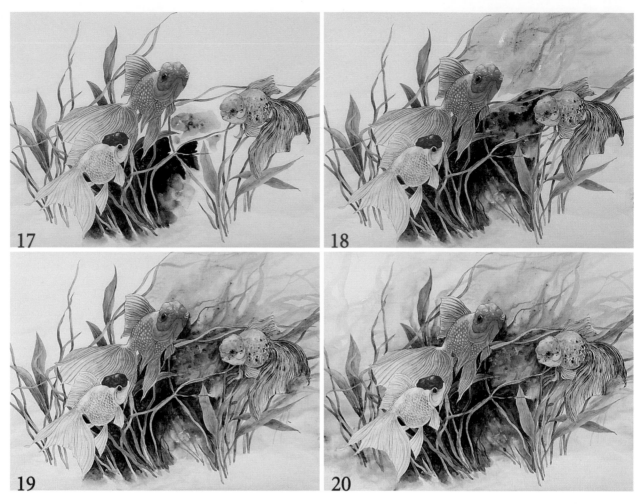

17 Paint the background

Use a large brush to mix yellow, Carmine and a little Indigo. Paint the area between the fish without touching the plants. While the colors are wet, use a small brush to add intense ink to define the edges of the fish and plants.

18 Continue painting the background

Use a large brush to wet the upper right quarter of the background. Apply yellow, Indigo and a little Vermilion to it. While the colors are wet, paint the distant plants with light ink and Indigo.

19 Continue painting the background

Use the small brush to define the edge of the top fish with intense ink. Blend the ink into the other colors at right. Next, wet the background at the middle right. Apply yellow and a little Vermilion to it. Then paint the distant plants with ink and yellow.

20 Continue painting the background

Wet the left side of the background. Paint light yellow and Indigo on it. Leave some white at the upper left corner.

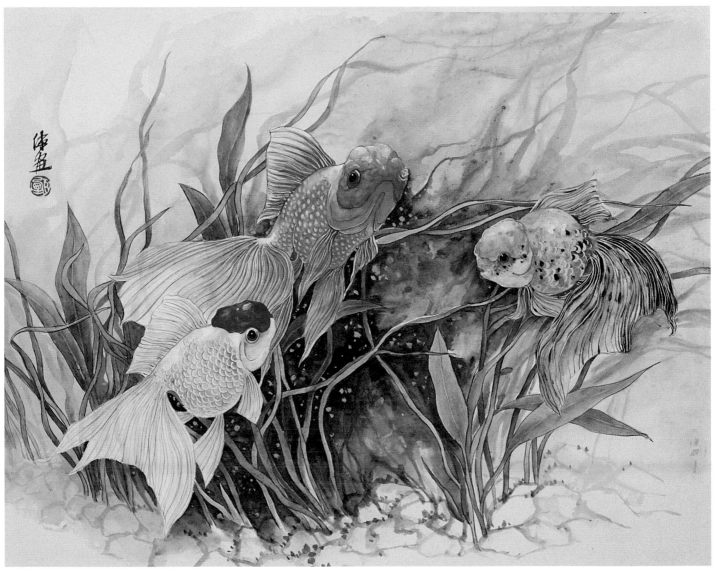

21 PAINT THE ROCKS, SIGN AND SEAL YOUR PAINTING

Use a medium brush and ink to outline the rocks. Fade out the distant rocks by using lighter ink. Mix intense blue and green to paint some spots on the intense color area between the fish, a technique referred to as *calling out the moss*. Finally, sign your name and stamp your chop on the upper left.

THREE GOLDFISH
15" x 19" (38cm x 48cm)
Chinese ink and colors on mature Shuan paper
Detail style

PAINTING A LIONFISH IN HALF-DETAIL, HALF-SPONTANEOUS STYLE

Strong color contrasts can create very interesting paintings. For instance, the rear fish has black stripes that cause the red fish in the front to pop out. The background for the red fish is in dark colors, while the background for the rear fish is in light colors.

1A

1B

1 A & B SKETCH THE FISH ON TRACING PAPERS

Sketch the fish separately on two sheets of 8" x 10" (20cm x 25cm) tracing paper. First use a pencil to draw the outlines, then use an ink pen to draw over the pencil lines and add more details.

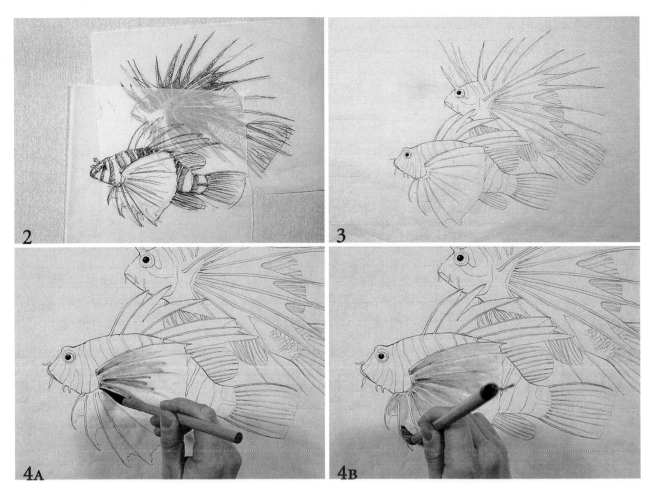

2 *Arrange the fish to create a good composition*

Arrange the sketches until you find a composition you like. In this composition, the back fish is flipped from its original position.

3 *Outline the fish with ink*

Overlay an 18" x 24" (46cm x 61cm) piece of mature Shuan paper on the sketches. Use an extra-small brush to outline the fish. Hold the brush straight. Paint the eyes with intense ink. Paint the heads, edges of the fins and tails with medium ink. Use light ink to outline the other parts.

4 A & B *Tone the pectoral fin of the front fish*

Get two large brushes to do toning. One is for inking and the other is for wetting and blending. Wet the fin without touching its bones. Next, apply medium ink at the beginning of the fin. Use the blending brush to drag and blend the ink to the tip of the fin. Leave the bones unpainted.

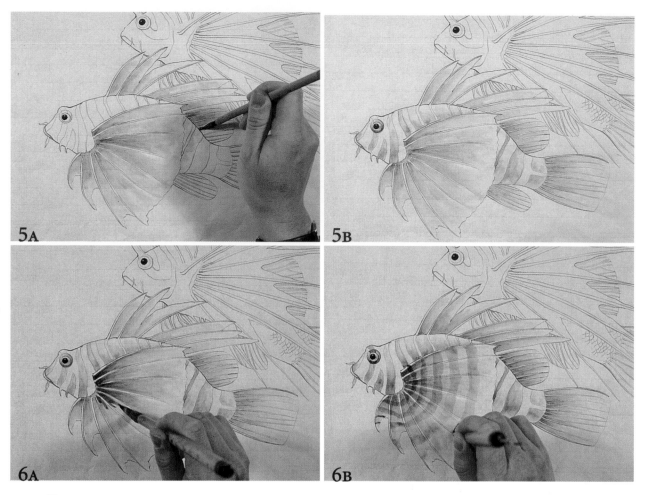

5 A & B *T*ONE THE OTHER PARTS OF THE FISH

Tone the other parts of the fish in the same way. Use smaller brushes
to paint the tiny areas. Leave white areas on top of the body.

6 A & B *A*DD A SECOND LAYER OF TONING TO
THE PECTORAL FIN

After the ink is dry, use the same brushes but more intense ink to tone
the pectoral fin in the same way. When the ink is almost dry, use the
inking brush to paint the stripes. Use intense ink for the stripe at the
beginning of the fin and lighter ink toward the tip.

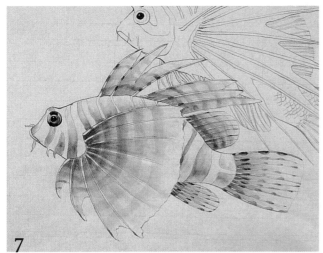

7 *APPLY A SECOND LAYER OF TONING TO*
THE OTHER PARTS OF THE FISH
Tone the dorsal fin similar to the way you did the pectoral fin. Apply more intense ink at the eye, body and tail. Use a small brush to paint the small dark spots on the fins and tail.

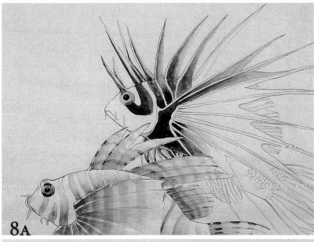

8 A & B *TONE THE BACK FISH*
Tone the back fish in the same way as the first fish. Starting in the darkest areas, apply very intense ink on the ventral and anal fins. Also, tone the pectoral fin with more intense ink than used for the dorsal fin of the front fish.

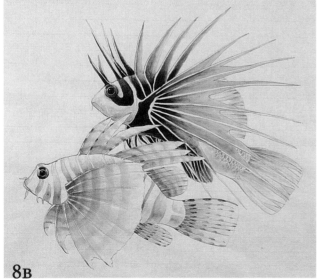

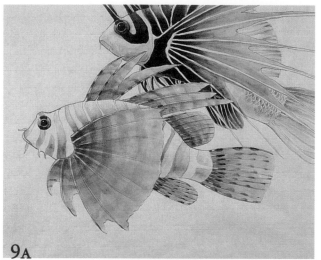

9 A & B APPLY THE FIRST LAYER OF COLORING TO THE FRONT FISH

Use a large brush to wet the fish, then apply yellow and Vermilion. Get more yellow to paint the body. Use a small brush to mix blue and Indigo to paint the eye.

9A

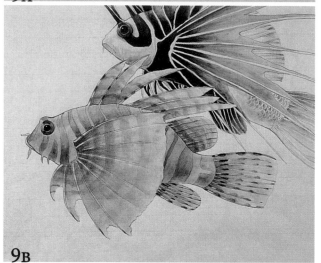

9B

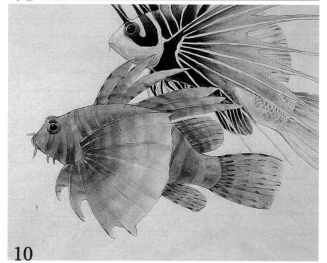

10 APPLY THE SECOND LAYER OF COLORING TO THE FRONT FISH

After the first layer of color is dry, lightly wet the fish again. Apply light Rouge. Paint lighter color on the tips of the fins and tail.

10

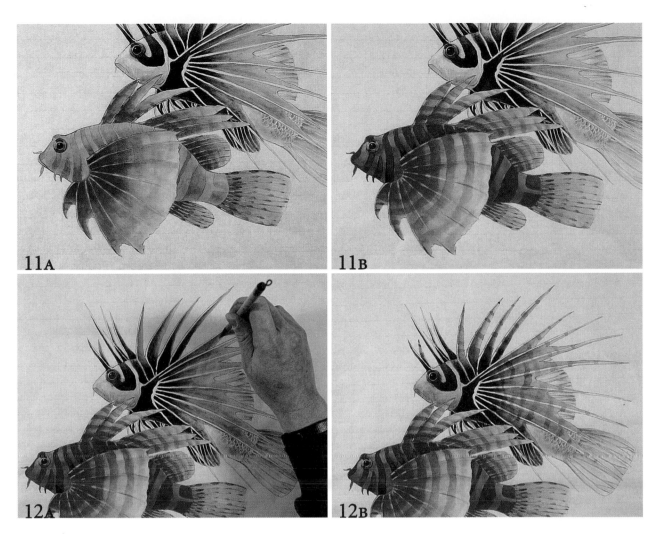

11 A & B ADD THE THIRD LAYER OF COLORING
TO THE FRONT FISH

Wait for the second layer of colors to dry. Lightly wet the fish again.
Use a medium brush to mix Rouge and ink to paint the lower portions
of the dark stripes. Then use another medium brush to blend the col-
ors toward the upper portions. Use a large brush to paint the stripes
on the fins with Rouge, intense at the beginnings and light at the tips.

12 A & B COLOR THE BACK FISH

Lightly wet the back fish. Use a medium brush to apply blue on the
fins, tail and lower half of the head. Apply yellow on the upper portion
of the head, the tips of fins and the body. After the colors are dry, light-
ly wet the fish again and apply the same colors a second time. Next,
use a medium brush to paint the stripes on the fins with Indigo and
light ink.

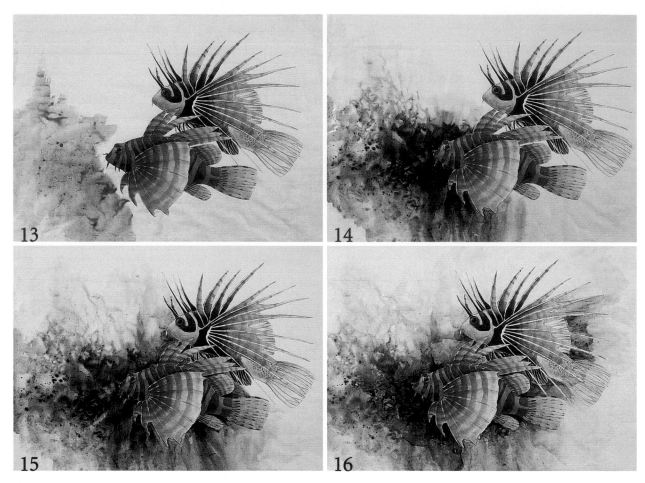

13 PAINT THE BACKGROUND AT LEFT

Use a large brush to wet the background, then paint the area with Phthalocyanine Blue, yellow and Vermilion. Use another large brush to blend the colors.

14 CONTINUE PAINTING THE BACKGROUND

Apply more intense yellow and Phthalocyanine Blue, then splatter Cinnabar on the area. Use a medium brush to apply intense ink and carefully define the outlines of the front fish. Next, drag the colors to the upper left to create the illusion of plants and moving water.

15 PAINT THE CENTER PART OF THE BACKGROUND

Wet the center area. Apply Phthalocyanine Blue and Cinnabar on the middle bottom and between the fish. Use a small brush and add intense ink to define the outlines of the fish.

16 PAINT THE BACKGROUND AT RIGHT AND DEFINE THE ROCKS

Wet the background area at right, then apply ink and Phthalocyanine Blue on the right side of the rear fish. Apply light yellow at top right, next to the fish. Use a medium brush and ink to define the rocks.

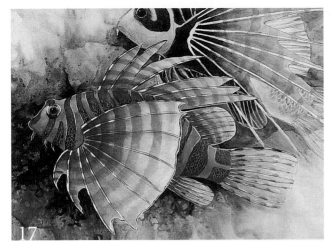

17 ADD DETAILS AND HIGHLIGHT THE FISH
Use an extra-small brush to mix very intense yellow and white. Highlight the bones on the fins and tails. In addition, paint the outlines on the head of the front fish. Next, mix Cinnabar and white to paint the scales on the front fish. Then use very intense white to highlight the dorsal and pectoral fins of the rear fish.

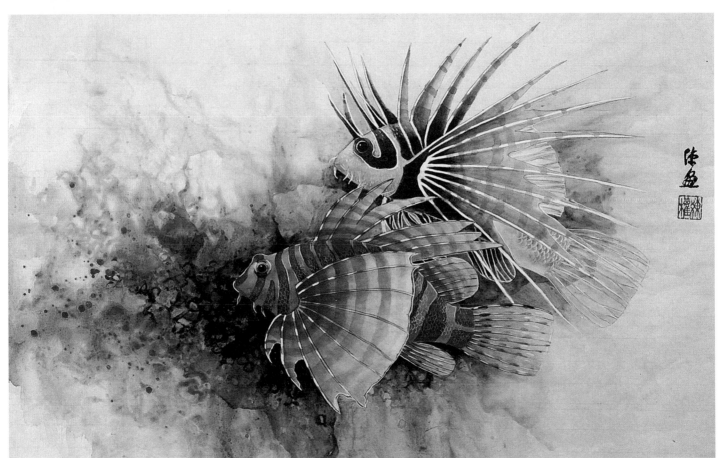

18 ADD MORE DETAILS TO THE REAR FISH, SIGN AND SEAL YOUR PAINTING
Use an extra-small brush to highlight the scales and upper eyeball with yellow and white. Also paint the texture of the gill and head. Next, paint the lower eyeball with Vermilion and ink. Finally, sign your name and stamp your chop at middle right. This area needs objects to balance the motions of the fish.

LIONFISH
18" x 24" (46cm x 61cm)
Chinese ink and colors on mature Shuan paper
Half-detail, half-spontaneous style

PAINTING BUTTERFLY FISH IN SPONTANEOUS STYLE

This is an ink-pouring type of painting. You will pour colors and ink on the raw Shuan paper. Then you will adjust the images according to the result you get from the pouring.

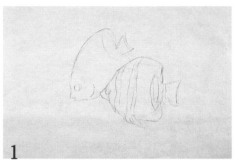

1 SKETCH THE FISH AND PREPARE THE COLORS

Use a charcoal stick to sketch the main outlines of the fish on 16" x 23" (41cm x 58cm) double-layer raw Shuan paper. Get the three small dishes you used for the watercolor painting in chapter four to prepare the colors. Squeeze about ½" (12mm) pigment from yellow, Cinnabar and Phthalocyanine Blue tubes into the dishes, placing one color per dish. Then dilute each with about ¼ cup (6ml) of water in each dish.

2 POUR THE COLORS

Use a 4-inch to 5-inch (10cm to 13cm) flat brush to wet the center part of the painting where the two fish are located. Pour the yellow on the yellow fish area and the Phthalocyanine Blue on the bluish fish area.

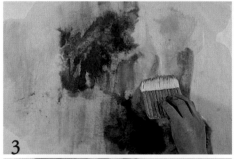

3 DIRECT THE BLENDING OF THE COLORS

Pour the Cinnabar on the head area of the bluish fish and on the upper head and body areas of the yellow fish. Use a flat brush to drag the yellow toward the lower left. In addition, drag the Phthalocyanine Blue to the upper middle.

4 APPLY INK ON THE BACKGROUND

Soak a large brush with intense ink and paint the area around the fish. Use a medium brush to define the outlines of the fish. Next, use a medium brush to paint the water plants at lower left with the colors and ink.

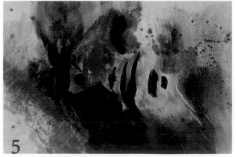

5 CONTINUE PAINTING THE BACKGROUND AND START PAINTING THE FISH

Pour more yellow on the upper left. Use a large brush to mix light ink and Phthalocyanine Blue. Splatter the colors randomly on the background. Use a medium brush to paint the eyes and the black stripes on the fish with intense ink. On the bluish fish, paint yellow on the mouth, Cinnabar on the head and Rouge around the eye.

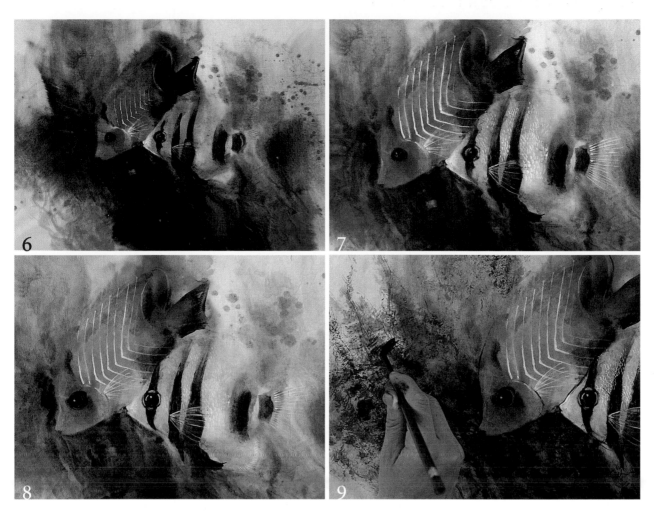

6 CONTINUE PAINTING THE FISH

Use a medium brush and intense white and yellow to paint the yellow fish's mouth and pectoral fin. On the bluish fish, use a small brush and very intense white to define the gill and pectoral fin. In addition, highlight the dorsal fin and the tail with very intense blue. Next, use a small brush to paint the stripes with very intense yellow and white.

7 CONTINUE PAINTING THE FISH

When the painting is halfway dry, some of the colors on the fish will have soaked into the paper. Apply more colors to the fish. On the yellow fish, use a small brush and very intense white and yellow to paint the scales and tail. On the bluish fish, paint the stripes again with intense white and yellow.

8 PAINT THE FISH EYES

Use a small brush to mix intense yellow, Cinnabar and a little white. Paint the highlights on the pupils and the outlines of the yellow fish's eyes. Apply a little intense Cinnabar on the bottom of the eyeballs.

9 PAINT THE BACKGROUND AGAIN

When the painting is dry, the background colors around the mouths and heads will not be intense enough. Use a medium brush to paint more intense ink strokes on the background. Next, make the brush into a split tip to paint some dry brushstrokes to abstractly depict the water plants.

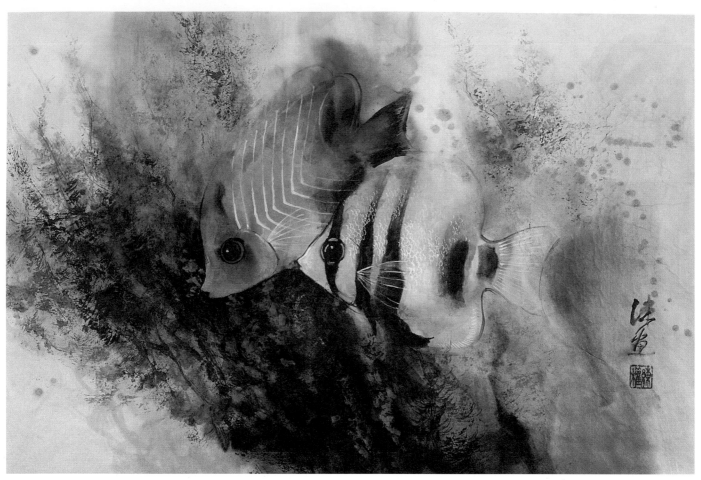

10 APPLY COLORS ON THE BACKGROUND AGAIN, SIGN AND SEAL YOUR PAINTING

Use a large brush to mix intense blue and Indigo. Apply the colors to the background. Use a small brush to outline the yellow fish with ink. Finally, sign your name and stamp your chop on the lower right corner.

TWO BUTTERFLY FISH
16" x 23" (41cm x 58cm)
Chinese ink and colors on double-layer raw Shuan paper
Spontaneous style

PAINTING ANGELFISH

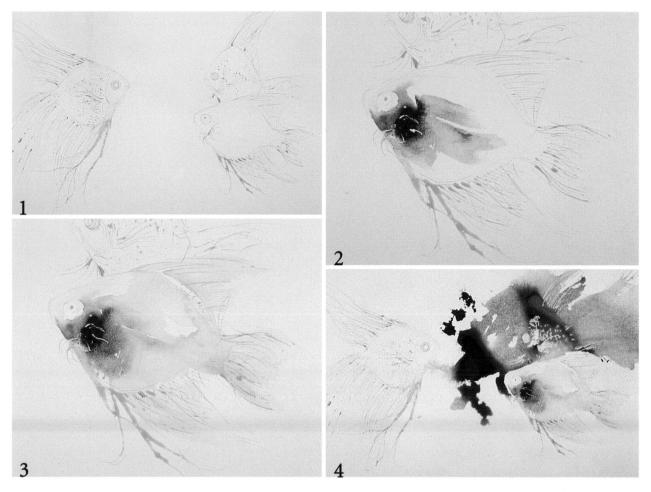

1 Sketch the fish and apply the Miskit

Using a pencil, lightly sketch the fish on a 14" x 21" (36cm x 53cm) 140-lb. (300gsm) cold-press watercolor paper. Apply Miskit with a bamboo pen or an Incredible Nib. Try to use thin strokes on the fins and tails. Next, prepare the three colors as you did on page 87.

2 Paint the white angelfish

Dry the Miskit with a hair dryer. Use a ¾-inch (19mm) flat brush to wet the head, gill and body. Next, use a no. 10 round brush to apply yellow around the eye and on the gill. While the colors are wet, apply very intense red on the gill and blue on the body. Let the colors blend into each other.

3 Paint the body and fins

Use a ¾-inch (19mm) flat brush to apply light yellow on the upper part of the body and light blue on the lower part. Leave a white line in the center of the body to depict the spine. Paint the fins and tail with very light yellow.

4 Pour the colors on the upper-right quarter of the painting

Wet the area with a water sprayer without spraying the white fish. Pour yellow on the fish and blue and red around the fish. Blow the colors from the upper left toward the corner and let the colors blend into each other.

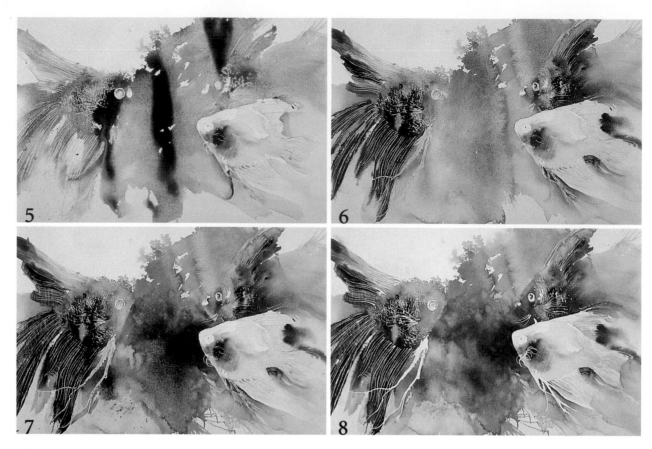

5 POUR THE COLORS ON OTHER AREAS OF THE PAINTING

Wet the remaining areas without wetting the white fish. Pour yellow on the dorsal fin and head of the left fish, red on the body and blue on the other fins and tail. Use a 1-inch (25mm) flat brush to drag the colors into the background against the white fish to define its tail and fins.

6 ABSORB THE EXCESS COLORS AND PAINT THE TWO YELLOWISH FISH

Use paper towels to absorb the excess colors. Then use a ³/₄-inch (19mm) flat brush to mix very intense blue and a little red. Paint the black stripes and fins. Apply more red on the dorsal fin of the fish at upper right.

7 PAINT THE BACKGROUND AND THE BONES ON THE WHITE FISH

While the colors on the background are wet, use a ³/₄-inch (19mm) flat brush to paint intense blue and red in the areas behind the white fish and the ventral fins of the fish at left. This will create depth as well as strong contrast for your painting. Next, splatter yellow and red on the background. Now the colors on the white fish should almost be dry. Use a no. 6 round brush to paint the bones next to the gill with clear water. The water will push away the colors and create lighter-colored strokes.

8 DRY THE PAINTING AND LIFT THE MISKIT

Use a hair dryer to dry the painting. Lift the Miskit with masking tape.

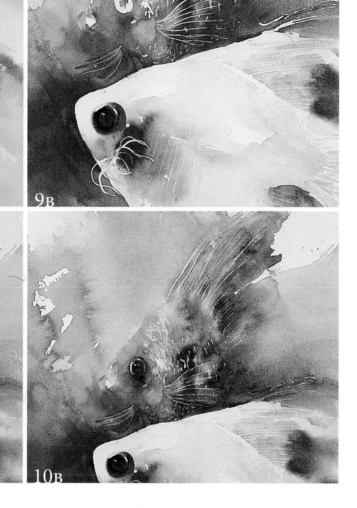

9 A & B PAINT THE FINS, TAIL AND EYE OF THE WHITE FISH

Use a no. 6 round brush to paint light yellow on the white lines of the dorsal, ventral and anal fins and the tail. On the pectoral fin, paint light red. Next, use a no. 10 round brush to paint intense red on the eyeball. Immediately use another no. 10 round brush to paint around the eyeball with blue. Then mix very intense blue and red to paint the pupil. Leave a white spot on the pupil for highlights.

10 A & B PAINT THE SCALES, FINS, TAIL AND EYE OF THE FISH AT UPPER RIGHT

Use a no. 6 round brush to paint the white lines on the scales, fins and tail with colors similar to their backgrounds. Next, mix yellow and red into light orange to paint the eye. Then add a more intense orange on the lower part of the eye. With very intense blue and red, paint the pupil and the outline of the eye.

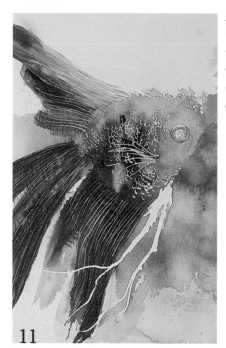

11 PAINT THE FINS, TAIL AND EYE OF THE FISH AT LEFT
Use a no. 6 round brush to paint the white lines of the scales, fins and tail with colors similar to their background. On the beginning of the ventral fin, use a wet paper towel to scrape out the colors so the connection between the fin and body is smooth. Next, paint the eye and define the head and mouth using light orange.

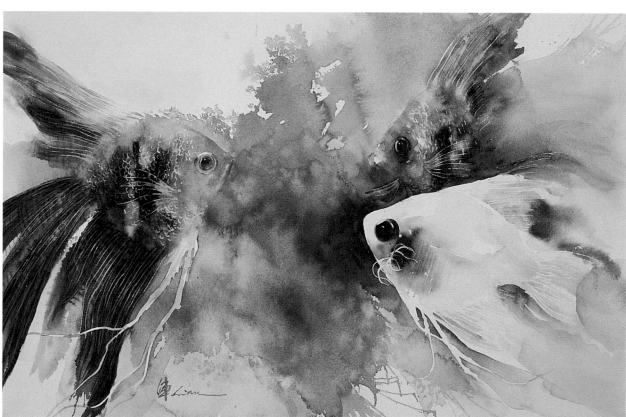

12 FINISH THE EYE AND SIGN YOUR NAME
Outline the eye of the fish at left with dark red, mixing red and blue.
Paint the pupil with very intense blue and red. Finally, sign your name
at bottom left next to the ventral fin of the fish at left.
THREE ANGELFISH
14" x 21" (36cm x 53cm)
Watercolor on Arches 140-lb. (300gsm) cold-press watercolor paper
Color pouring and blending

PAINTING KOI

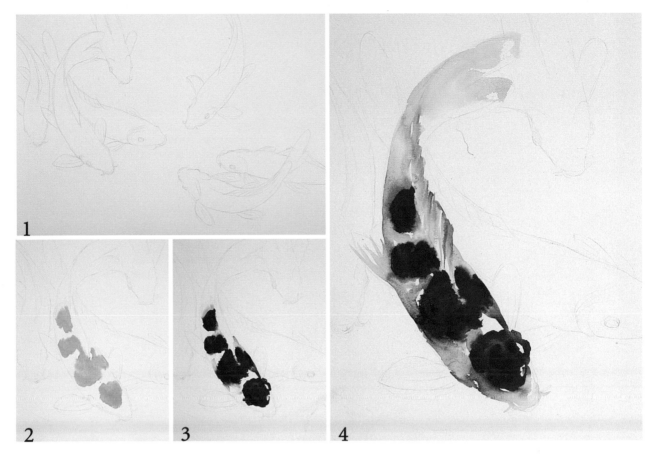

1 SKETCH THE FISH AND PREPARE THE COLORS

Use a pencil to lightly sketch the fish on a 21" x 29" (53cm x 74cm) 140-lb. (300gsm) cold-press watercolor paper. Prepare the three colors as you did on page 87, but use double the amounts of the pigments and water.

2 PAINT THE FRONT FISH AT LEFT

Use a 1-inch (25mm) flat brush to wet the intense red color areas of the front fish's body. Apply intense yellow on the wet areas.

3 PAINT INTENSE RED ON THE FISH BODY

Use a 1-inch (25mm) flat brush to add very intense red to the yellow. Next, mix the red with a little blue to paint the lower portions of the red colors. This will depict the volume of the body.

4 PAINT THE BODY, MOUTH, FINS AND TAIL

While the colors are wet, use a wet ³/₄-inch (19mm) flat brush and a little light blue to paint the body. Let the colors blend. Use a no. 10 round brush to paint the mouth and barbels with light yellow and red. Next, mix light blue, red and a little yellow to paint the tail in three strokes. Use a wet ³/₄-inch (19mm) flat brush to drag the colors from the body to paint the ventral fin. Then mix medium blue and red to paint the dorsal fin.

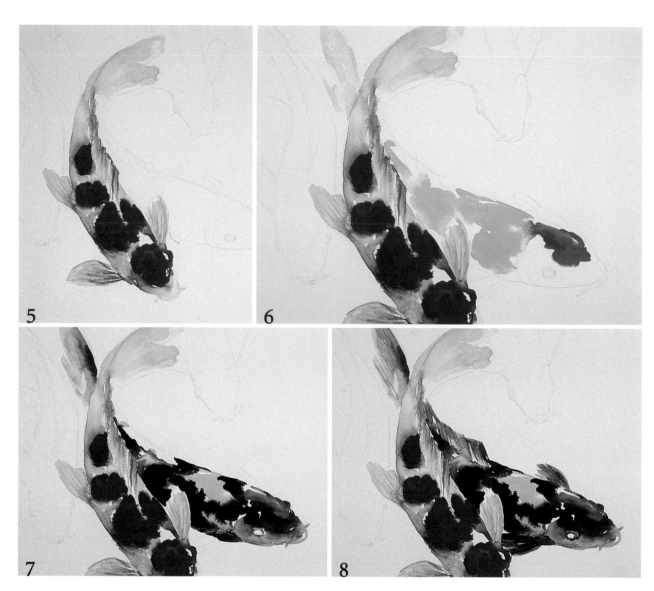

5 CONTINUE PAINTING THE FINS AND TAIL

Use a ¾-inch (19mm) flat brush to apply yellow and red on the fins. When the colors are almost dry, add intense yellow and red strokes to the dorsal fin. Also paint light yellow on the tail.

6 PAINT THE YELLOW-BLACK FISH

Use a 1-inch (25mm) flat brush to wet the fish, randomly leaving small dry spots on the head and upper part of the body. Apply intense yellow to the head, body and tail. While the color is wet, apply red on the head.

7 PAINT THE BLACK PATTERN ON THE FISH

Immediately use a 1-inch (25mm) flat brush and intense blue and red to paint the black patterns. Next, paint the mouth and gill with orange mixed from yellow and red. Let the black blend into the gill and mouth.

8 PAINT THE FINS AND OUTLINE THE EYE

Use a ¾-inch (19mm) flat brush and yellow to paint broad strokes for the fins. Then paint small strokes with blue and red to define the fins' textures. Also, paint a few small strokes on the tail to depict its bones. Next, use a no. 6 round brush to paint the outline of the eye with intense blue and red. Paint the upper area of the eye with red and a little yellow.

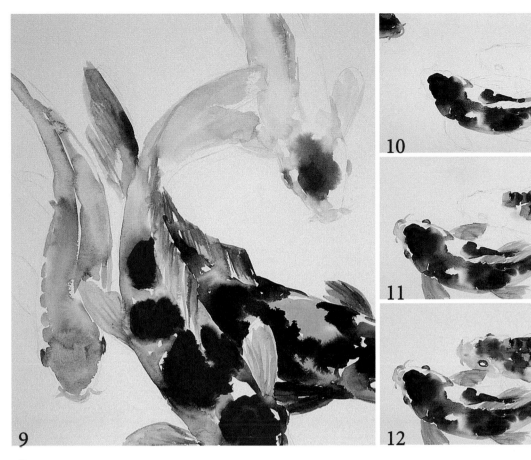

9

10

11

12

9 PAINT THE TWO DISTANT FISH

To paint the fish at right, use a ¾-inch (19mm) flat brush to wet it. Apply medium red on its head. Mix light yellow and red to paint the mouth, body and fins. Leave some white on the right side.

To paint the fish at left, wet it without touching its dorsal fin, then use a ¾-inch (19mm) flat brush to paint the body with blue. Next, mix yellow and red to paint its head, fins, tail and body outline. Finally, use a no. 10 round brush to paint its eye with blue.

10 PAINT THE FISH AT LOWER RIGHT

Wet the fish, leaving dry areas on its dorsal fin, head and body. Use a 1-inch (25mm) flat brush to paint intense red on the head and body. Next, paint intense blue on the head, gill and body. Use a wet 1-inch (25mm) flat brush to drag the colors from the body to paint the tail.

11 PAINT THE FINS, MOUTH AND EYE AND START
PAINTING THE FISH ABOVE

Use a ¾-inch (19mm) flat brush to paint the fins and mouth with light yellow and red. Use a no. 10 round brush to paint the eye with blue. To paint the fish above, use a ¾-inch (19mm) flat brush to paint some blue strokes for its scales. Immediately apply intense blue and red on the left side of the blue strokes to define the scales.

12 CONTINUE TO PAINT THE FISH ABOVE

Use a ¾-inch (19mm) flat brush to apply medium red to the head and body. Paint the lower part of the body with light yellow. Next, drag the colors from the body to paint the dorsal fin and gill. Paint the mouth with light yellow and red.

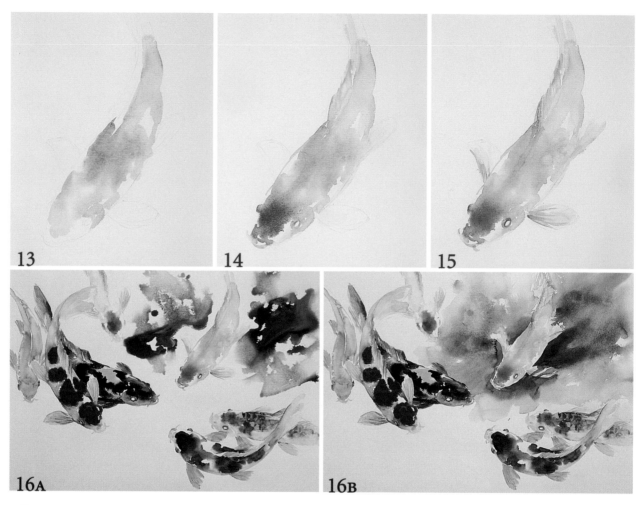

13 PAINT THE BODY OF THE FISH AT MIDDLE RIGHT

Use a 1-inch (25mm) flat brush to heavily wet the body, leaving a few dry areas. Apply light red and blue to the body. Let the colors blend into each other.

14 PAINT THE HEAD, MOUTH, FINS AND EYES

Use a ¾-inch (19mm) flat brush to paint the head with red. Use a no. 10 round brush to paint the mouth with a little yellow. Next, paint the dorsal fin with light yellow and blue. Then use a no. 10 round brush to paint the eyes with blue.

15 PAINT OTHER FINS AND ADD MORE DETAILS

Use a moist ¾-inch (19mm) flat brush to drag the colors from the body to paint the ventral fin. Next, paint the pectoral fins with light red and blue. Use a no. 6 round brush and red to add the texture on the dorsal fin. Apply one stroke from the dorsal fin toward the head with water to create the top edge of the fish. Also, drip some water on the body as bubbles.

16 A & B PAINT THE UPPER-RIGHT QUARTER OF THE BACKGROUND

Paint the background when the colors on the fish are almost dry. Use a 1½-inch (38mm) flat brush to wet the area without touching the fish. Pour the colors. Use a ¾-inch (19mm) flat brush to guide the colors toward the fish. Blow the colors toward the fish tail at upper center with your mouth. Use paper towels to absorb any excess liquid. Next, use the ¾-inch (19mm) brush to mix intense blue and red to define the edge of the fish.

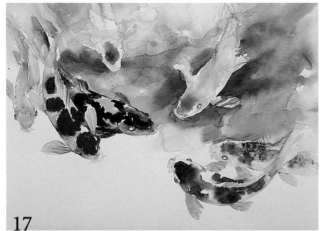

17 PAINT THE UPPER-LEFT QUARTER OF THE BACKGROUND

Wet the upper left background area without wetting the fish. Pour blue and a little red on it. Use a 3/4-inch (19mm) flat brush to guide the colors so they do not flow into the fish. Next, mix intense blue and a little red to paint the water against the head of the distant fish at upper left. In addition, use light blue to paint a few strokes over the tail and body of the fish to depict the water.

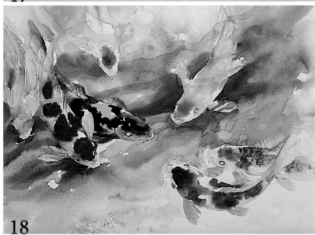

18 PAINT THE LOWER-LEFT QUARTER AND MIDDLE AREA OF THE BACKGROUND

Wet the lower-left and middle background areas without touching the fish. Pour yellow from the lower center toward the lower left. Pour blue on the lower left. Blow the colors toward the lower middle area. Use a 3/4-inch (19mm) flat brush to mix intense blue and red to paint the water against the heads of the red fish and the distant fish at left.

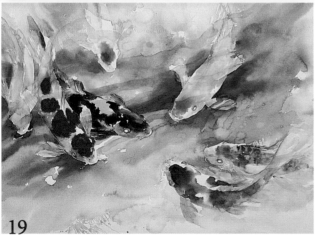

19 PAINT THE LOWER-RIGHT QUARTER OF THE BACKGROUND

Also wet the lower-right background area without touching the fish. Use a 3/4-inch (19mm) flat brush to apply blue between the fish toward the lower right corner. Drag the colors into the two fish to paint a few strokes as water. Paint yellow on the body and ventral fin of the curled fish.

20 PAINT THE EYE AND ADD DETAILS ON THE RED FISH

Use a no. 6 round brush to mix blue and red into dark purple. Paint the outlines of the eye. Mix very intense blue and red into black to paint the pupil, leaving a white spot as the highlight. Next, paint intense red strokes on the pectoral and ventral fins. Also, paint the texture of the gill using light red and blue.

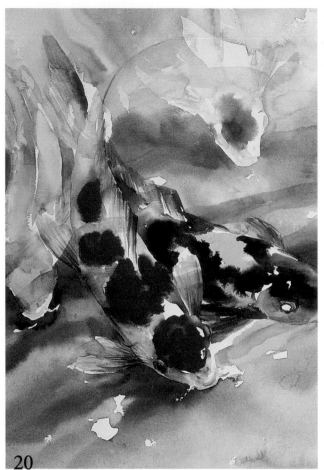

21 A & B PAINT THE EYES, GILLS AND FINS OF THE OTHER FISH

Use a no. 6 round brush to paint the eyes, gills and fins in a manner similar to that in the previous step, as shown in these two illustrations.

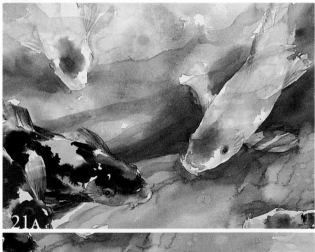

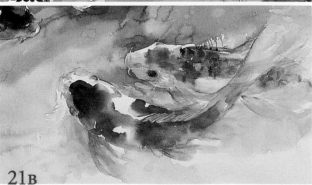

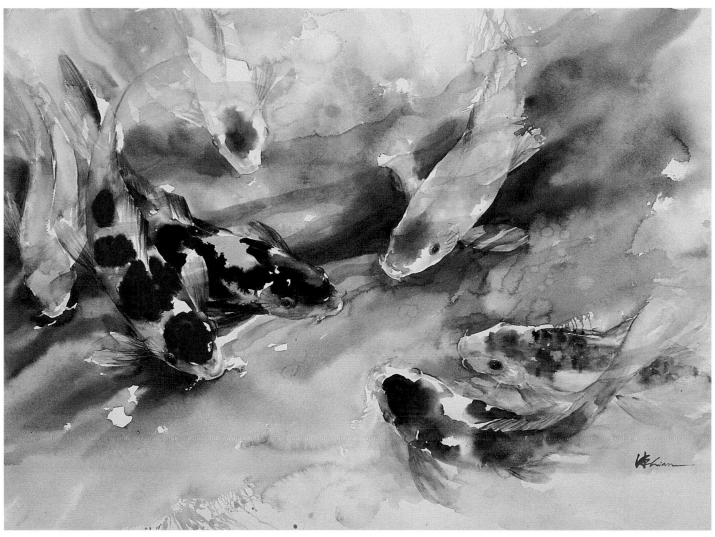

22 Sign your name

Sign your name on the lower right corner. This will balance the composition because there are more objects and action on the left side of the painting.

KOI
21" x 29" (53cm x 74cm)
Watercolor on Arches 140-lb. (300gsm) cold-press watercolor paper
Color pouring and blending

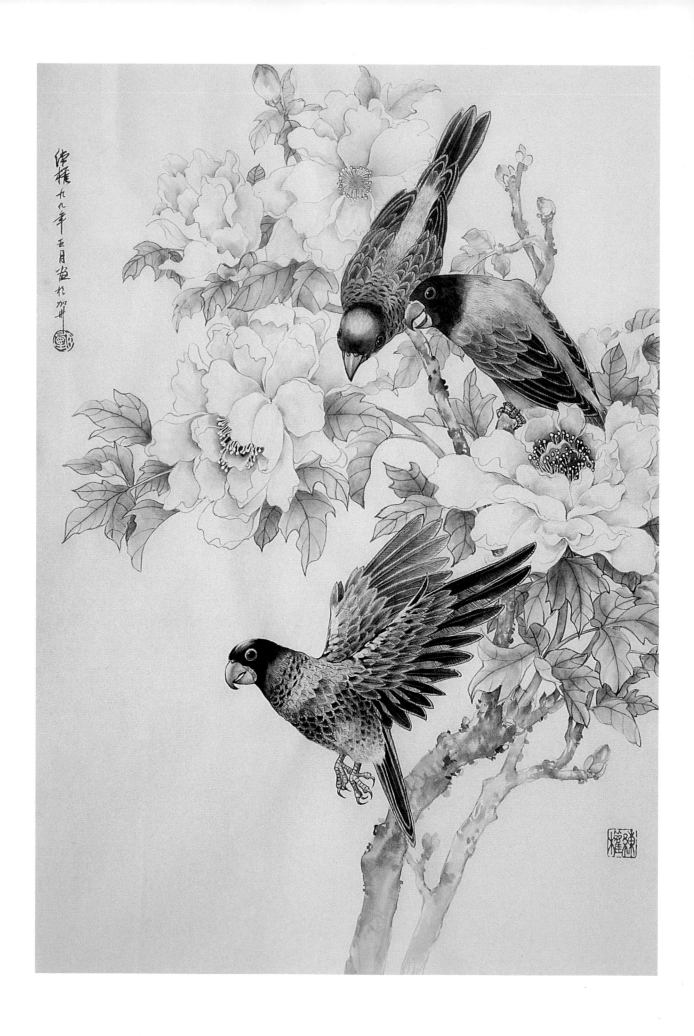

Conclusion

Chinese painting experience is of great benefit to me and my watercolors. It is not important to differentiate the painting styles. Instead, learn and take advantage of Chinese painting, watercolor and other cultures' arts. Then create paintings that reflect the changing and progressing world.

My paintings focus on freedom and creation, and I will continue to work hard along that track. I am greatly rewarded if you found this book helpful to you and your artistic creations.

THREE PARROTS AND PEONY
17" x 24" (43cm x 61cm)

MATERIALS

For Chinese painting demonstrations in this book (also see pages 16-18):

Brushes: Extra-small, small, medium and large soft- and hard-fur 4-inch (102mm) or 5-inch (127mm) flats

Colors: Gamboge, Vermilion, Indigo, Cinnabar, Burnt Sienna, Phthalocyanine Blue, White, Carmine (Marie's Chinese Painting Colors)

Paper: Rice, Shuan (mature, double- and single-layer), tracing

Other: Ink, Rouge, foamcore board, tape, ink pen, chop (optional), charcoal stick, china palette or small dishes for colors

For watercolor demonstrations in this book (also see pages 58-59):

Brushes: Nos. 6, 8 and 10 rounds, 3 small brushes to mix paints, ¾-inch (19mm) flat, 1-inch (25mm) flat, 1½-inch (38mm) flat

Colors: Cadmium Red Deep (Winsor & Newton), Cadmium Yellow Light and Ultramarine Blue (Utrecht)

Paper: Arches 140-lb. (300gsm) cold-press watercolor paper

Other: Grumbacher's Miskit Liquid Watercolor Frisket, 3M 1" or 1½" (3cm or 4cm) masking tape, 3' x 4' (91cm x 122cm) 3-ply plywood for working surface, soft-lead pencil, 3 small dishes for paint, hair dryer, Incredible Nib or bamboo pen, spray bottle, paper towels

RESOURCES

Amsterdam Art
1013 University Avenue
Berkeley, CA 94710
Phone: (800) 994-2787
Fax: (510) 548-6678
E-mail: mail@amsterdam.com
Web site: www.amsterdamart.com

This art supply store carries Sumi paper (Japanese paper similar to Chinese double-layer Shuan paper), brushes, inks, ink stones, ink sticks and Chinese colors.

Art Store, The
455 Fortune Boulevard
Milford, MA 01757
Phone: (508) 478-8914
Fax: (508) 473-3496
E-mail: order@artstore.com
Web site: www.artstore.com

This store carries Sumi paper, brushes, ink, ink stones, ink sticks, and colors.

Zhen Studio
P.O. Box 1060
Pinole, CA 94564
Phone and Fax: (510) 724-3971
E-mail: lianzhen@yahoo.com
Web site: www.zhenstudio.com

Another option for locating the materials listed above, including Chinese paper, brushes, ink, ink stones, colors, Rouge and chops, is to contact Lian Zhen.

INDEX